Monet
in London

This book is published
on the occasion of the exhibition
Monet in London
organized by the
High Museum of Art
Atlanta, Georgia
October 9, 1988 to January 8, 1989
sponsored by
The Coca-Cola Company
with additional support from

American Express Company
including
The Robinson-Humphrey Company

and from
RJR Nabisco

Published by the High Museum of Art
 Atlanta, Georgia
Distributed by the
University of Washington Press
 Seattle and London

Edited by Kelly Morris
Designed by Jim Zambounis
Type set by Katherine Gunn
Printed in Great Britain by
Balding + Mansell International Ltd.

Library of Congress No. 88-82269
ISBN 0-939802-50-3 (hard cover)
ISBN 0-939802-52-x (soft cover)

Cover: Cat. No. 21. *Houses of Parliament in the Fog*
(detail).

Monet
in London

Grace Seiberling

High Museum of Art
distributed by
University of Washington Press
Seattle and London

Preface

Claude Monet's series of paintings of specific subjects under varying conditions of light were based on his most intensive observations in order to enable him to reproduce the chromatic effects as accurately as possible. These series, for all their objective correctness, are regarded as milestones in the early evolution of modern art because of Monet's attempts to recreate changing visual facts through deeply personal interpretations which, to him, required a series of variations, of repetitions of a theme. It was the first time in the history of art that given subjects were translated into series of paintings which suggest shifts in movement and the passage of time.

This immersion of an entire artistic program in the observation of light by one of the great masters of painting appeared to us as the right theme for our celebration of the fifth anniversary of our building, an environment where light is the ultimate factor. It is the effect of natural light in the interior spaces which has given Richard Meier's building its undeniable magic, a quality which is produced on the exterior at night in an altogether different manner by artificial light. In choosing Monet's London series as the focus of our celebration, we were guided by the fact that we own a particularly fine example, *The Houses of Parliament in the Fog*, 1903, acquired for the collection in 1960.

Monet produced nearly one hundred paintings between 1899 and 1904 in the three series of London landmarks—Waterloo Bridge, Charing Cross Bridge and the Houses of Parliament—but when he showed these series to the public for the first time he included only thirty-seven works. The whereabouts of many of the paintings are not known today, but, fortunately, a number of the finest examples are in North American museums. It is our good fortune that we were able to bring together twenty-three paintings from the London series with the generous cooperation of virtually all of the American and Canadian museums that own examples. Inevitably, some paintings could not be made available for conservational reasons or because of conflicting plans. Regrettably, we could secure the loan of only one example of the London subjects from European collections.

The account in this catalogue of Monet's creation of the London series was written by Professor Grace Seiberling of the University of Rochester. We are deeply grateful to her for giving us insights not only into the artist's purposes with these images but into his working methods at the time. It emerges that the constant weather changes and the seasonal shifts of the sun induced Monet to work simultaneously on a dozen or more canvases in order to capture particular effects of daylight, producing color relationships which to him were especially beautiful. The frustrations of missing certain conditions because of the unpredictable weather, punctuated by moments of exhilaration, are vividly described in Dr. Seiberling's text. She worked closely with the High Museum's

4

Chief Curator, Dr. Donald Rosenthal, a scholar of French painting, in developing the premise for this study.

To pack and to move works of art of great value, and to present them in a comprehensive exhibition with illuminating information and a catalogue with good illustrations and original text is becoming an increasingly costly venture. Thanks to the contacts and efforts of certain members of our Board of Directors, we were given financial support by an extraordinary group of corporate sponsors: The Coca-Cola Company, American Express Company, including The Robinson-Humphrey Company, and RJR Nabisco, who joined forces in making this presentation of one of the great French masters possible in Atlanta. It is difficult to express adequately our gratitude to the leadership in these business organizations.

Finally, our recognition and thanks go to the lenders who were willing to make these rare and fragile works available to our project. We cannot produce exhibitions of importance without such collaboration.

Gudmund Vigtel
Director

5

Foreword

This exhibition provides a rare opportunity to see a series shown as Monet wished. In his later career, Monet did not think in terms of single paintings, but rather painted many versions of the same subject. The individual work gains its meaning in the context of the whole group, but the impact of the whole is greater than the sum of its parts. It is not the city which claims our attention in the London paintings, but the artist's cumulative vision of it.

Monet's *plein-airism* and his dedication to rendering the subtle effects he perceived are evident in these works; his artistry and painterly process are too. For the visitor to an exhibition as for the scholar, Monet's work rewards returning, re-viewing, and rethinking. In bringing these paintings together we hope to reveal some of the complexities of Monet's unique sensibility.

Such a project inevitably involves many people. In addition to Donald Rosenthal and the individuals he mentions, who have been very helpful, I would like to thank the lending institutions and members of their staffs, Bret Waller, who first conceived of the project, the Durand-Ruel Galleries, which supplied photocopies of press cuttings, and Carolyn Bloore, who located photographs and found information on turn-of-the-century London.

Grace Seiberling

Acknowledgements

Many people in Atlanta and elsewhere have contributed to the realization of this ambitious project. First among these I would like to thank our guest curator, Professor Grace Seiberling of the University of Rochester. In addition to making the initial selection of works for the show and writing the catalogue, Professor Seiberling has helped in innumerable ways with details of the installation and related programs. The exhibition is a tribute to her expertise on Monet's series paintings, among which the London pictures form such a significant part.

At the Memorial Art Gallery of the University of Rochester the Director, Grant Holcomb III, and the Curator of European Art, Bernard Barryte, graciously provided assistance when the High Museum decided to undertake this project. Others who have provided useful information or advice include Gerard Stora of Wildenstein & Co. and Dr. Michael Flack of M. Knoedler & Co., New York. The staffs of all the lending institutions have been most helpful in providing data and photography related to Monet's works.

Gudmund Vigtel, Director of the High Museum, has shown tireless enthusiasm for the project and has contributed greatly to the success of the loan requests. Vickie Mooney ably coordinated the events scheduled for the opening of the exhibition. Many Museum staff members have helped with various aspects of the exhibition, in particularly Dorothy Anderson, Vikki Baird, Sue Deer, Ellen Dugan, Sally Fulton, Paula Hancock, Marjorie Harvey, Steve Lindsley, Maureen Marks, Tami Lynn Piggott, and Woodie Wisebram. The catalogue, designed by Jim Zambounis, was managed by Museum editors Kelly Morris, Amanda Woods, and Susan Davis. Finally, I wish to express my appreciation to Margaret Miller, who coordinated countless details during every phase of the project.

Donald A. Rosenthal
*Chief Curator and
Curator of European Art*

Monet
in London

Titles for Monet's paintings throughout 7
the book are those employed by the
lending institutions. The French titles in
brackets are as given by Monet or his
principal dealer, Galerie Durand-Ruel,
or as they appear in the catalogue
raisonné by Daniel Wildenstein. Monet's
paintings are further identified by
Wildenstein numbers, preceded by "W."
Monet's letters are designated by
Wildenstein numbers preceded by "w."

Unless otherwise noted, all illustrated
works are by Monet and are oil on
canvas. Dimensions are given in inches
and centimeters, height before width.
Captions note the catalogue number for
works in the exhibition. See page 101 for
a complete checklist.

Introduction

In 1904 Claude Monet exhibited thirty-seven views of Charing Cross Bridge, Waterloo Bridge, and the Houses of Parliament in the Paris galleries of his dealer, Durand-Ruel. They were chosen from among nearly one hundred paintings which presented a very individual and distinctive view of London and the Thames.[1]

The paintings show the foggy river and city surrounding it under gray skies or when the sun penetrated the fog or illuminated smoke. In the morning, as Monet looked east, the light was behind Waterloo Bridge. Later in the day he painted the afternoon light picking out the columns which ornamented the bridge. As he followed the course of the sun, he looked toward Charing Cross Bridge and painted midday and afternoon effects. He frequently depicted the dazzling reflections on the water as he looked toward the sun. When the sun was fairly high in the sky a shadow was cast nearly directly under the bridge, but he also showed shadows and reflections of the sun beginning to set. The views of the Houses of Parliament were done late in the day, with effects of the sun setting and the light fading.

This cycle of time is also one of weather. In some of the paintings the fog is only a thin veil, punctuated by smoke (fig. 38); in some, the fog is thicker, and takes on color (fig. 63); in others it is so dense that it almost blots out the buildings and chimneys in the distance and threatens to obscure the bridges or Houses of Parliament (figs. 15, 49).

To paint so many views of these three aspects of a single subject may seem a natural consequence of the Impressionist wish to record light and atmosphere and to capture evanescent effects. The paintings are an expression both of Monet's long-term interests and of his particular concerns and circumstances at the turn of the century.

When Monet began the London paintings in the fall of 1899 he was nearly fifty-nine, and a successful and sought-after artist. He had come a long way from the early days when his work had been harshly criticized for its lack of finish and unnatural color. But while he could count on a cordial reception and buyers for his paintings, he continued to be concerned with many of the same challenges that he had struggled with in his early days: how to note his impression of a fleeting moment; what it meant to finish a picture. Paintings did not come easily to this acknowledged master; these views of the Thames, which convey a sense of a spontaneous response to shifting, momentary effects, resulted from five years of work.

This period of work in London, with its stays in a first-class hotel and its freedom to paint for extended periods, was not Monet's first trip to the city. He had fled to England to avoid military service during the Franco-Prussian War in 1870-71. His first wife, Camille, whom he had recently married, and their

8

1. Daniel Wildenstein, *Claude Monet: Biographie et catalogue raisonné*, 4 vols. (Lausanne and Paris: Bibliothèque des arts, 1974-1985), 4: nos. 1521-1617. Hereafter numbers from the catalogue of paintings will be cited with "W."

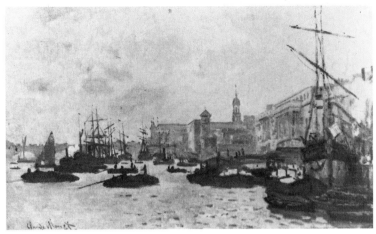

Fig. 1. *Boats in the Pool of London*, 1871, 18½ x 28¾ inches (47 x 73 cm), private collection.

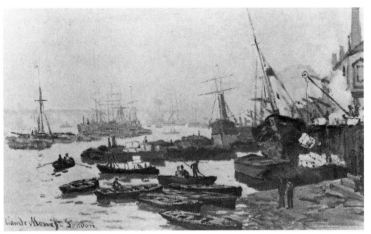

Fig. 2. *The Pool of London*, 18½ x 28⅜ inches (47 x 72 cm), private collection.

three-year-old son Jean were with him. He was unknown and had very little money. Monet was not nostalgic about this earlier period; when he was in London in 1900 he referred to "the miserable time passed here" thirty years before.[2] Despite its difficulties, it had in some ways been a fruitful time for his art and for his career. At a café frequented by French painters the artist Daubigny introduced Monet to Paul Durand-Ruel, who would become his most important dealer and his single most important source of income for much of his life. Durand-Ruel informed him that fellow Impressionist Camille Pissarro was also in London, and the two artists looked at paintings together, and made their first views of the city.[3]

During this first stay Monet painted two misty views of parks.[4] He also painted views of the Thames. Two of them, *Boats in the Pool of London* and *The Pool of London* (figs. 1, 2), show boats in the river and buildings on its banks. A third, *The Thames below Westminster* (fig. 5), however, has many features that link it to Monet's later views of the Thames. It was painted from the Victoria Embankment, close to the location from which he would later paint, looking toward Westminster Bridge and the Houses of Parliament, which are veiled by fog in the distance. The tonal quality of the painting and the way Monet created an atmospheric effect with soft blues and yellows suggest that he was already seeing London as a source for effects of fog.

2. Ibid., letter no. 1530 to Alice Monet, London, Friday, 16 March [1900]. Hereafter letters from the Wildenstein catalogue will be cited in the text with "w." and the number. In the letter Monet mentioned a Dr. Vintras, whom he had known before, but whom he avoided because he feared he might still owe him money. Wildenstein, *Monet*, 1: 52 gives some details of Monet's stay.

3. Wynford Dewhurst printed a letter from Pissarro in his 1904 book, *Impressionist Painting: Its Genesis and Development*, quoted in Camille Pissarro, *Letters to his Son Lucien*, ed. John Rewald, rev. ed. (Santa Barbara and Salt Lake: Peregrine Smith, 1981), p. 470. "We also visited the museums. The watercolors and paintings of Turner and of Constable, the canvases of Old Crome, have certainly had influence upon us. We admired Gainsborough, Lawrence, Reynolds, etc., but we were struck chiefly by the landscape-painters, who shared more in our aim with regard to 'plein air,' light, and fugitive effects." See Alan Bowness, *The Impressionists in London*, exhibition catalogue (London: Arts Council of Great Britain, 1973).

4. *Hyde Park*, W. 164, Rhode Island School of Design Museum of Art, and *Green Park*, W. 165, Philadelphia Museum of Art.

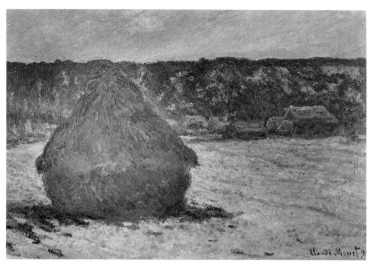

Fig. 3. *The Haystacks in the Snow, Overcast Day*, 1891, 26 x 36⅝ inches (66 x 93 cm), The Art Institute of Chicago, Mr. and Mrs. Martin A. Ryerson Collection.

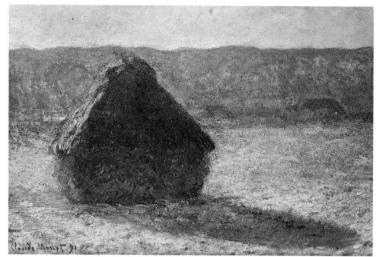

Fig. 4. *Landscape with a Haystack* [*Effet de neige, le matin*], 1891, 25⅝ x 36¼ inches (65 x 92 cm), Museum of Fine Arts, Boston, gift of Misses Aimee and Rosamond Lamb in memory of Mr. and Mrs. Horatio A. Lamb.

10

The first paintings Monet had made in 1870 were a group of related but separate works (figs. 1, 2, 5). Almost thirty years later, when he began his London series, Monet's approach had changed. He was still an Impressionist in the sense that he painted–as Castagnary had put it in 1874–"not the landscape but the sensation produced by the landscape."[5] But he was no longer satisfied by independent works that recorded effects that interested him. Around 1890 he had begun to work increasingly in multiple versions of the same motif, and by the end of the 1890s virtually all of his work was done in series. This practice had begun in a formalized way with the Haystacks, which he exhibited as a group in 1891.

He had painted the Haystacks in a field, changing canvases as he observed the changes in light (figs. 3, 4). He began to seek exceptional times of day such as sunset, when the entire scene was transformed in color. The group of paintings had a unity that came both from the repetitions of form and from the interrelations of color and atmospheric effects.

The repetitions in the series overcame some of the difficulties of painting effects of light and atmosphere that lasted only minutes. The repeated formats provided a point of reference. But a series was not merely a practical means of achieving naturalistic results; it was also a way of creating something that went beyond the spontaneously noted individual work to create a larger whole. Monet moved from an attention to specific aspects of his motif and contrasts

5. Jules Castagnary, "L'Exposition du boulevard des Capucines: Les Impressionnistes," *Le Siècle*, 29 April 1874, reprinted in Anne Dayez-Distel et al., *Centenaire de l'impressionnisme*, exhibition catalogue (Paris: Grand Palais, 1974), p. 265.

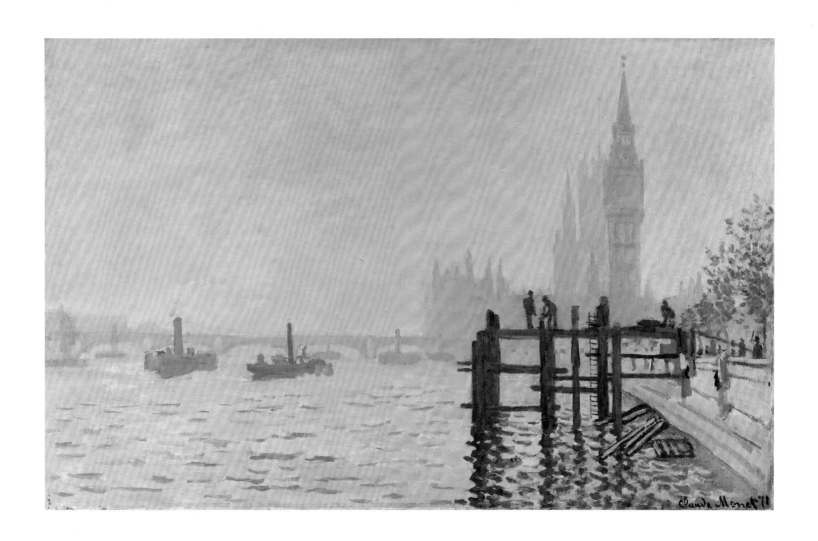

11

Fig. 5. *The Thames below Westminster* [*La Tamise et le Parlement*], 1871,
18½ x 28¾ inches (47 x 73 cm), The National Gallery, London.

12

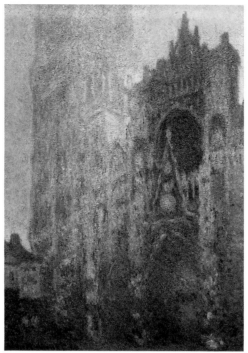

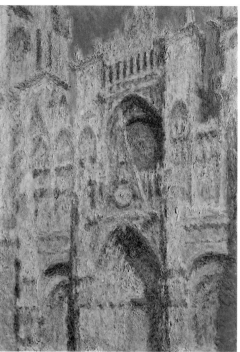

Fig. 6. *Rouen Cathedral, Tour d'Albane, Early Morning*, 1894, 41¾ x 29⅛ inches (106 x 74 cm), Museum of Fine Arts, Boston, Tompkins Collection.

Fig. 7. *Rouen Cathedral* [*Soleil*], 1894, 39⅜ x 25⅝ inches (100 x 65 cm), The Metropolitan Museum of Art, bequest of Theodore M. Davis, 1915, The Theodore M. Davis Collection.

within it to a concern for atmospheric effects that gained their significance in combination with other paintings in the group.

An American painter, Theodore Robinson, described a conversation with Monet in 1892 in which the artist said that he regretted that he could no longer paint in the same spirit as before.

> At that time anything that pleased him, no matter how transitory, he painted, regardless of the inability to go further than one painting. Now it is only a long continued effort that satisfies him, and it must be an important motif, one that is sufficiently seductive. "Certainly one loses on the one hand if one gains on the other. One can't have everything. If what I do [now] no longer has the charm of youth, I hope that it has more serious qualities, that one can live longer with one of these canvases."[6]

He talked with Robinson while he was working on his Cathedrals, which he would later compare in interest to the Thames paintings (w. 1537) (figs. 6, 7).

6. Diary of Theodore Robinson, 3 June 1892, Frick Art Reference Library.

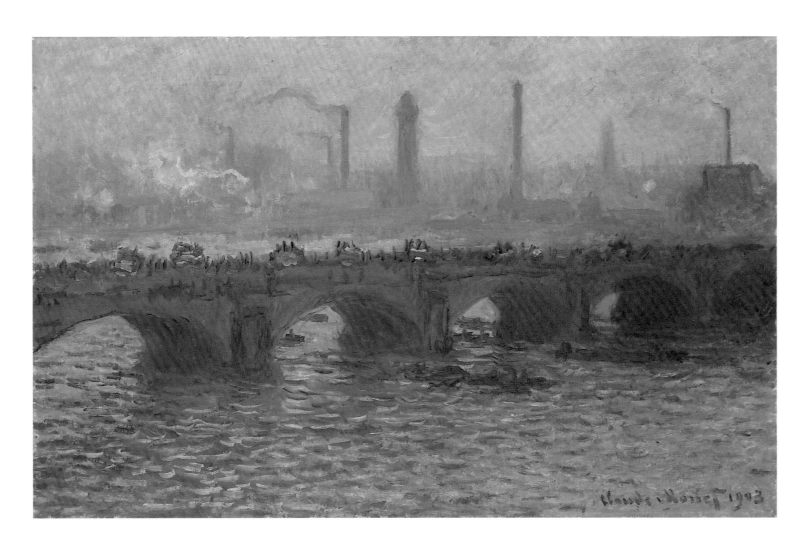

13

Fig. 8. *Waterloo Bridge, temps gris,* 25¾ x 39½ inches (65.4 x 100.3 cm),
The Ordrupgaard Collection, Copenhagen. Cat. no. 8.

Fig. 9. *A Morning on the Seine*, 1897, 35⅜ x 36½ inches
(89.9 x 92.7 cm), The Art Institute of Chicago, Mr. and
Mrs. Martin A. Ryerson Collection.

As with the London paintings, he had looked at his motif from a window,
changing the canvases as the light changed; he returned with unfinished
canvases the next year; and he spent a long time finishing the paintings in
the studio. He chose to view the Cathedral at different times of day when the
light gave the scene a visual and emotional unity that was reinforced in the
simplified composition.

Monet's return to the Thames came at a time when he was revisiting other
sites where he had painted earlier. He later told Thiébault-Sisson that since his
sixtieth birthday (which was in 1900) he had the idea

> to take up each of the categories of motifs which have shared my attention in
> turn, to create a kind of synthesis where I would sum up, in one canvas, some-
> times two, my impressions and my sensations of the past.[7]

Although he said he had given up the idea, in fact he had begun to revisit
motifs earlier; he had gone back to Pourville in 1896 and 1897 and had
returned to one of his perennial subjects, the Seine, both earlier in the 1890s
and in the Mornings on the Seine of 1896-97 (fig. 9). But he could never sum

14

7. François Thiébault-Sisson, "Un nouveau
musée parisien: Les Nymphéas de Claude
Monet: L'Orangerie des Tuileries," *Revue de
l'art ancien et moderne* 52 (1927): 48, reprinted
in Charles F. Stuckey, ed., *Monet: A Retrospec-
tive* (New York: Park Lane, 1985). The author
visited Monet in 1918.

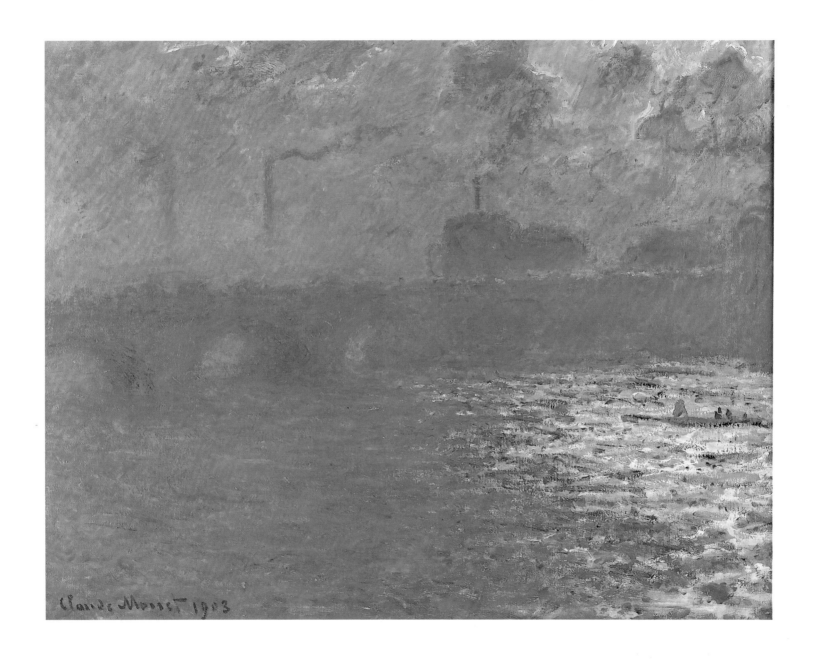

Fig. 10. *Waterloo Bridge, effet de soleil*, 29¹/₁₆ x 36⁵/₈ inches (73.8 x 93 cm),
Milwaukee Art Museum, bequest of Mrs. Albert T. Friedmann. Cat. no. 12.

16

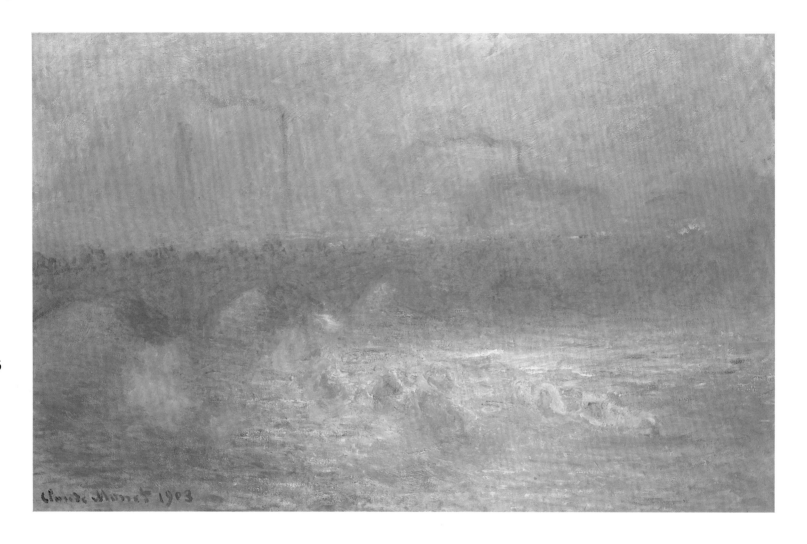

Fig. 11. *Waterloo Bridge* [*Effet de soleil avec fumées*], 26 x 39¾ inches (66 x 101 cm), The Baltimore Museum of Art, The Helen and Abram Eisenberg Collection. Cat. no. 11.

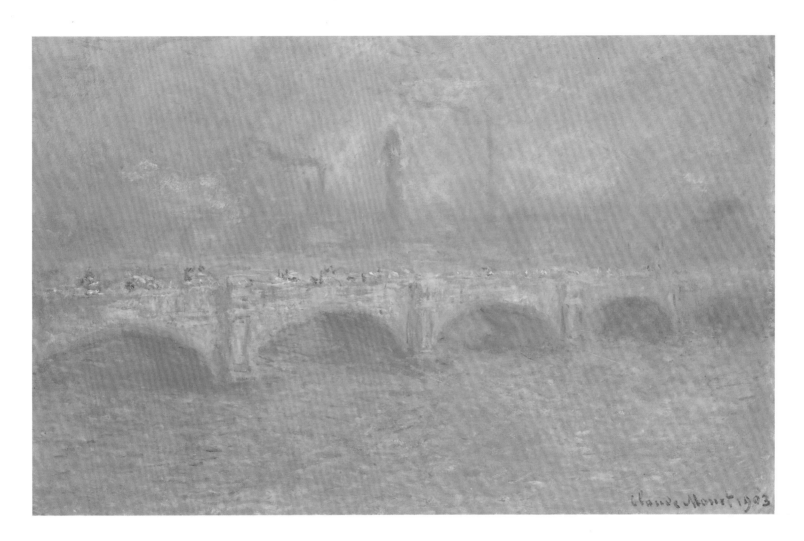

Fig. 12. *Waterloo Bridge* [*Effet de soleil*], 25⁷/₈ x 39³/₄ inches (65.7 x 101 cm),
The Art Institute of Chicago, Mr. and Mrs. Martin A. Ryerson Collection.

Fig. 13. *London, Westminster, Savoy Hotel from Embankment,* 1893, photograph, Royal Commission on the Historical Monuments of England.

8. Wildenstein, *Monet,*4: 5 records that his income in 1900 was 213,000f; 127,500 for 1901; 271,0000 for 1904 (plus interest), in contrast to 13,938 for 1880. (His account books are missing for the early 1890s.) According to *Homes of the Passing Show* (London: The Savoy Press, 1900), p. 104, in 1900 5 francs were equal to $1 or 4 shillings.

up his impressions in one or two paintings. He was driven to paint many canvases. Rather than emphasizing different times of day, these series of the later 1890s dealt with subtle and delicate atmospheric effects. So when Monet finally revisited London, he had already been working on effects of mist and fog.

Monet conceived of his London paintings as a series from the start. This meant that he knew he would be painting many works, and that he chose a vantage point that would provide him with repeatable motifs. It also meant that he knew he would need a long period of work, and that, judging from his past experience, it might be several years before the series was finished.

While there were many artistic reasons for the evolution of the series as a way of working, the phenomenon could only come about at a point in Monet's life when he could afford to take the time and risk involved in an extended group of paintings which would not be ready for immediate sale. By the 1890s he had an established reputation as an artist and could sell his work for relatively high prices. He could afford to go for long periods without exhibitions and sales.[8] He also could be confident that there was a market for many versions of the same subject.

In 1899, 1900, and 1901, in contrast to the modest lodgings he had lived in during his first visit to London, he stayed at the Savoy, which was one of the city's most elegant hotels. It had opened in 1889. A promotional book pub-

18

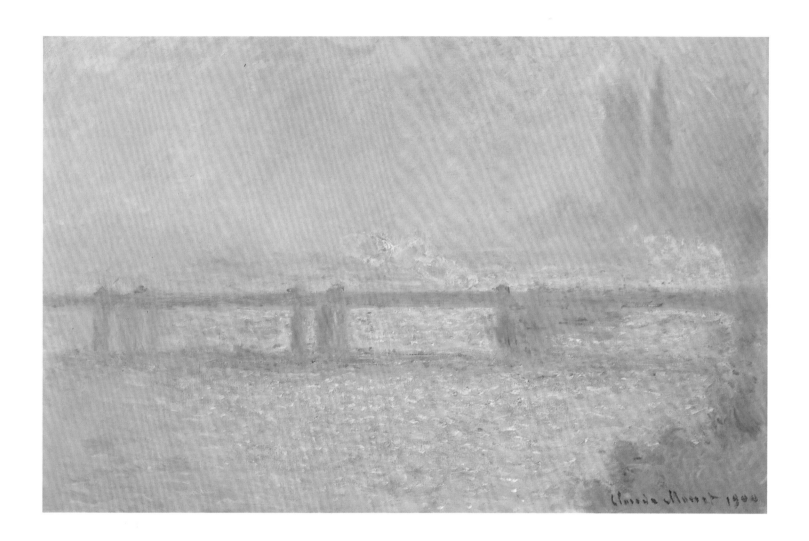

Fig. 14. *Charing Cross Bridge* [*Temps couvert*], 23⅞ x 36 inches (60.7 x 91.4 cm), Museum of Fine Arts, Boston, gift of Janet Hubbard Stevens in memory of her mother, Jane Watson Hubbard. Cat. no. 2.

lished in 1900 boasted of its smoky and vaporous views of the Thames as well as its luxuries.[9] Besides its view, one feature that Monet appreciated was the sun balconies across its front, from which he could paint.[10] Its restaurant was noted, and its grill room, where Monet most frequently dined, then (as now) had an excellent reputation.[11] Although the Savoy's location was no doubt the primary attraction, Monet certainly enjoyed good food and comfortable surroundings, and at this point in his career he could afford them. When he returned in 1904, however, he complained that the Savoy had become *too* sumptuous (w. 1750).

Despite his elevated circumstances, Monet still found painting difficult. His stated goals were simple. At the end of his life, he wrote: "I have always had a horror of theories . . . my only merit is to have painted directly from nature in seeking to render my impressions before the most fugitive effects."[12] The wish to paint directly and to render momentary effects involved the artist in contradictions that he himself acknowledged when he wrote in 1892, "I am seeking the impossible" (w. 1151).[13] He could not paint without the knowledge of what he and others had done before; his view of nature was inevitably mediated. And the increasingly evanescent impressions that he sought to note later in his life lasted such a short time, and were so variable, and so frequently failed to return, that he could not render them directly. His frustration at falling short of his goals and his difficulties in the execution of his projects sometimes led him to conceal his actual practice, both in the works—he said that he wanted to prevent people "from seeing how it is done"[14]—and in his discussions with interviewers.

The London paintings embody the paradoxes of Monet's naturalism: the wish to complete instantaneous notations of transient effects, and to retain spontaneity in laboriously reworked paintings, and to achieve both a convincing illusion and a satisfactory personal expression.

Many of the Thames paintings present the illusion of momentary perceptions of particular places under specific conditions of light and weather. However, looking at these works, especially as a group, is very different from the experience of looking at the sites. The paintings also reflect a complex artistic process and reveal many ambiguities in their making and interpretation. They seem to have been painted rapidly and spontaneously; seen close up, their brushwork—which at a distance resolves itself into a naturalistic effect—seems almost random. In fact, the paintings involved long and deliberate work. The effects appear almost effortless, but the series took years to complete and caused the artist great anguish.

Monet himself created a myth of the spontaneous outdoor painter. This was not so much a lie as a statement of an ideal, which he was always falling short of

9. Elizabeth Robins Pennell, "Out of our Window," *Homes of the Passing Show*, p. 17, "Indeed, it is in its infinite variety, due chiefly to smoke and atmosphere, that the Thames is unrivalled." This was a frankly Whistlerian point of view; his "Ten O'Clock" lecture was quoted and his *Savoy Pigeons* was illustrated. An anonymous French contributor described the view of "the broad Thames flowing with its waves shimmering under the rays of a lovely May sun lightly veiled by this soft London vapor which . . . melts the colors, softens the harsh protrusions and gives to buildings an air simultaneously mysterious and stylish."

10. Eric de Maré, *London's Riverside: Past, Present and Future* (London: Max Reinhardt, 1958), p. 171. The balconies were later closed in and converted to bathrooms.

11. *Homes of the Passing Show* advertised "the most renowned and fashionable restaurant in the world, overlooking the River Thames and the Embankment Gardens, by day the most beautiful garden and river view in Europe, by night a fairy scene." Prices included bedrooms from 7s 6d a day, suites of apartments from 30s; luncheon 5s; dinner 7s 6d.

12. Wildenstein, *Monet*, 4: w. 2626, to E. Charteris, Giverny, 21 June 1926.

13. See Steven Z. Levine, "Monet's Series: Repetition, Obsession," *October*, no. 37 (Summer 1986): 65-75 for a discussion of this issue.

14. Maurice Guillemot, "Claude Monet," *Revue Illustré* 13 (15 March 1898) [n.p.], reprinted in Stuckey, *Monet: A Retrospective*.

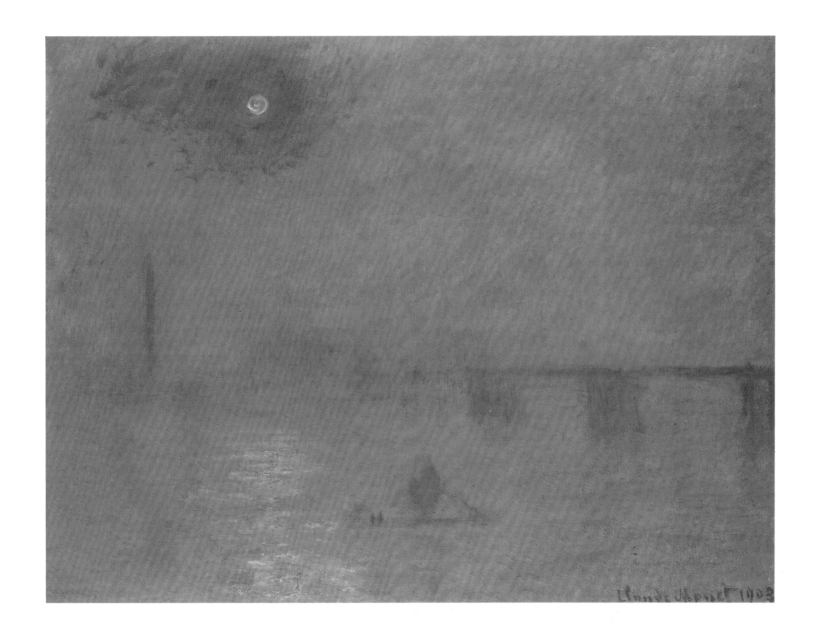

Fig. 15. *Charing Cross Bridge, Fog on the Thames* [*Brouillard sur la Tamise*],
29 x 36³⁄₈ inches (73.7 x 92.4 cm), The Harvard University Art Museums
(Fogg Art Museum), gift of Mrs. Henry Lyman.

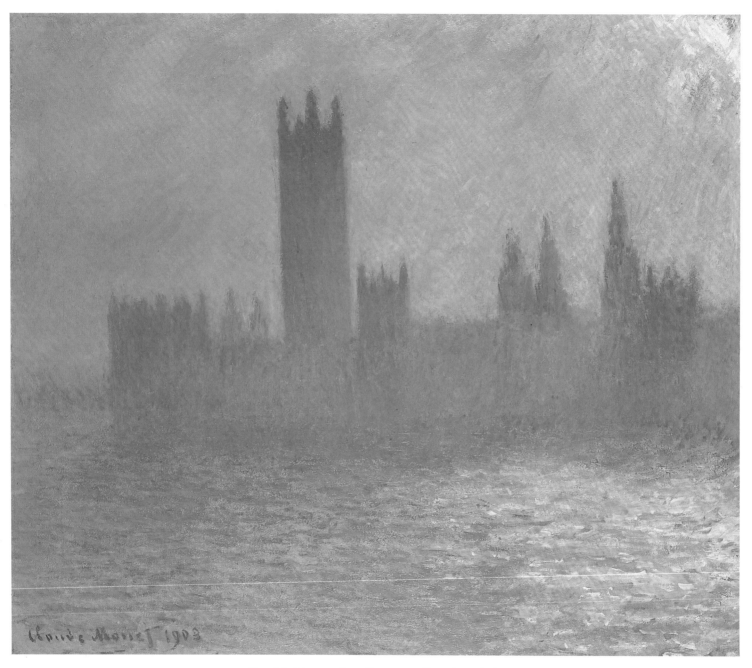

Fig. 16. *Houses of Parliament, Effect of Sunlight*, 32 x 36¼ inches (81.3 x 92 cm),
The Brooklyn Museum, bequest of Grace Underwood Barton. Cat. no. 19.

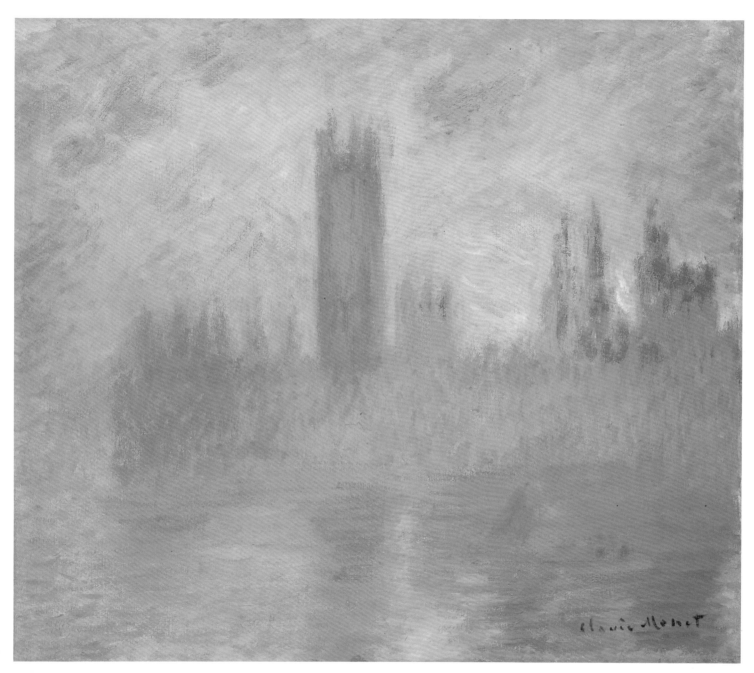

23

Fig. 17. *Houses of Parliament* [*Tours de Westminster*], 31⅞ x 36¼ (81 x 92 cm),
The Art Institute of Chicago, Mr. and Mrs. Martin A. Ryerson Collection. Cat. no. 20.

attaining. The artist's practice of continually returning to his paintings and reworking them can be seen as an obsession, and Levine has proposed that it is connected with madness and melancholy.[15] The multiple periods of work on the paintings were an indication of Monet's inability to get it right the first time, but they also became a feature of his later style. The effects he achieved came to depend upon a complex process. The Thames paintings show a balance between the direct response to nature and the struggle to make the beginnings into the result that he imagined.

Chronology of the Series

The history of Monet's work on the Thames series is not that of individual paintings completed one by one, but rather of an extended project, of work on a group of canvases. As the task became more complicated, its completion was deferred; more and more canvases were begun and required more work in the studio. The painting in London was itself planned and put off many times.

As with many aspects of the project, Monet minimized the effort and reflection that went into it when he talked to an interviewer in 1904. He made it sound like an accident that he had painted the Thames, and also indicated that he had done more of the painting on the spot than was the case. Maurice Kahn reported:

> The greatest of chances brought Monet to London. He accompanied the youngest of his sons to choose a pension for him. He didn't think of painting. He had only brought several small canvases: "for the sketches [*pochades*]." And he was supposed to stay a week. He put up at the Savoy Hotel. His room looked out on the Thames; to the right, Charing-Cross bridge, to left, Waterloo bridge; there, close by, the Parliament. And all this bathed in a unique atmosphere. He stayed a month. He came back and remained three months. He came back during four following years.[16]

In fact, Monet had long considered painting in London. The immediate impetus for the series, as he indicated to Kahn, was a short trip that he made in 1898. He wrote to his dealer, Paul Durand-Ruel, that he had gone to London for two weeks in November because his son, Michel, who was studying English, was ill (w. 1416). He stayed at the Grosvenor Hotel, not the Savoy (w. 1417), and if he made sketches, they are not identifiable.[17]

Monet began the Thames series in the fall of 1899. He wrote to his dealer in October that he had been there for a month and had "tried to do some views of the Thames" (w. 1473). This first period of working is not very well documented, because his second wife, Alice, to whom he wrote nearly every day when they were separated, was with him. According to her journal, they left for London in mid-September and her daughter Germaine was along as well.

24

15. Steven Z. Levine, "Monet, Madness, and Melancholy," *Psychoanalytic Perspectives on Art*, ed. Mary Mathews Gedo, vol. 2 (Hillsdale, N.J.: The Analytic Press, 1987, distributed by Lawrence Eribaum Associates), pp. 111-32. Although he suggests that Monet was manic-depressive, he also states: "The madness and melancholy of Monet . . . seem to be as much artifacts of culture as disorders of personality."

16. Maurice Kahn, "Le Jardin de Claude Monet," *Le Temps* (7 June 1904), reprinted in Stucky, *Monet: A Retrospective*.

17. One sketchy painting of *Waterloo Bridge*, W. 1576 (private collection), which is smaller than all the others (60 x 73 cm.) might be such a sketch. John House, *Monet: Nature into Art* (New Haven and London: Yale University Press, 1986), p. 230, points out that there is a drawing of a silhouette of the Houses of Parliament seen from the Savoy Hotel in a sketchbook in the collection of the Musée Marmottan (inv. no. 5134, p. 18 verso), most of the drawings in which seem to date from 1890-1896 or 1897? Could Monet have made the trip Pissarro described in 1891? See note 29.

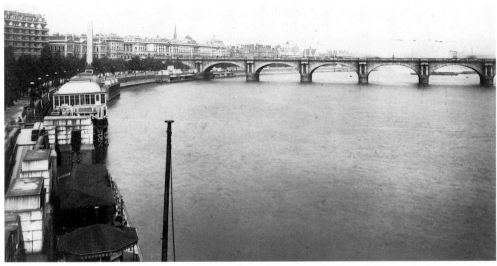

Fig. 18. *Westminster, London, Waterloo Bridge*, photograph, Royal Commission on the Historical Monuments of England. Tide is low in the Thames; the Savoy Hotel appears on the extreme left.

They went sightseeing with Monet's son, Michel, while Monet painted.[18] He worked in a room on the sixth floor of the Savoy Hotel from which, looking to the left, downstream, east and north, he had a view of Waterloo Bridge and, looking upstream, southwest, to the right, he could see Charing Cross Bridge, with Westminster Bridge and the Houses of Parliament in the distance.

When Monet went back to France from London in early November 1899, he brought a number of canvases of the Thames. Durand-Ruel marked eleven of them as ones he wanted. Monet wrote that he could assure him of at least five or six before his departure for London. "As for the others, I will do my best, you know that. Those that I can't finish off here, I will complete on the spot in London" (w. 1474). As was often the case, Monet was overly optimistic about finishing the works which he had described as "vague experiments" (w. 1482). Monet did not sell any of these paintings to Durand-Ruel in 1899, although he sold one (W. 1521, fig. 40) to Boussod and Valadon, another gallery.

Monet returned to London in February 1900, bringing the unfinished paintings with him. He wrote to Alice on his arrival at the Savoy Hotel that although he had been promised the same room as before, Princess Louise had selected it as one of the rooms to be reserved for wounded officers returning from the Boer War (w. 1503). Monet was offered instead two rooms on the floor below, nos. 541 and 542. The angle was less steep, but he was satisfied with the view. One of the rooms was for sleeping; the other, with the furniture removed, was

18. Wildenstein, *Monet*, 4: 6.

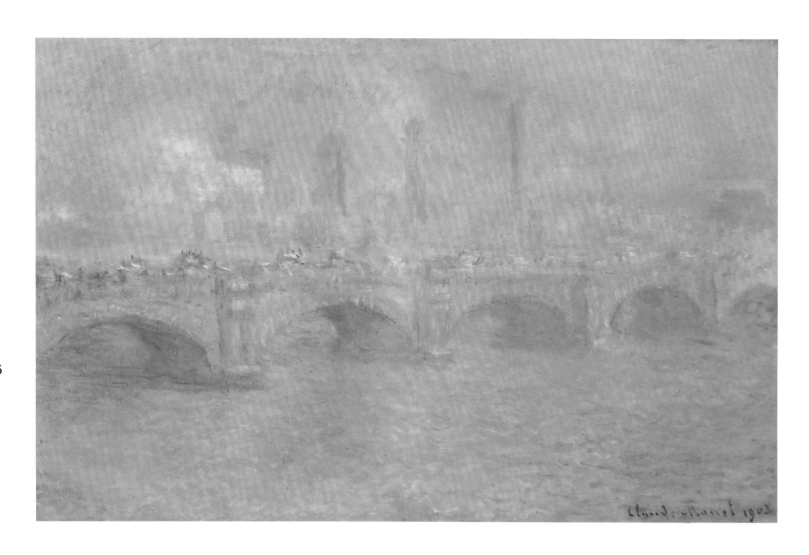

Fig. 19. *Waterloo Bridge* [*Effet de soleil*], 25¾ x 39½ inches (65.4 x 100.3 cm),
McMaster University, gift of Herman Levy, Esq., O.B.E. Cat. no. 16.

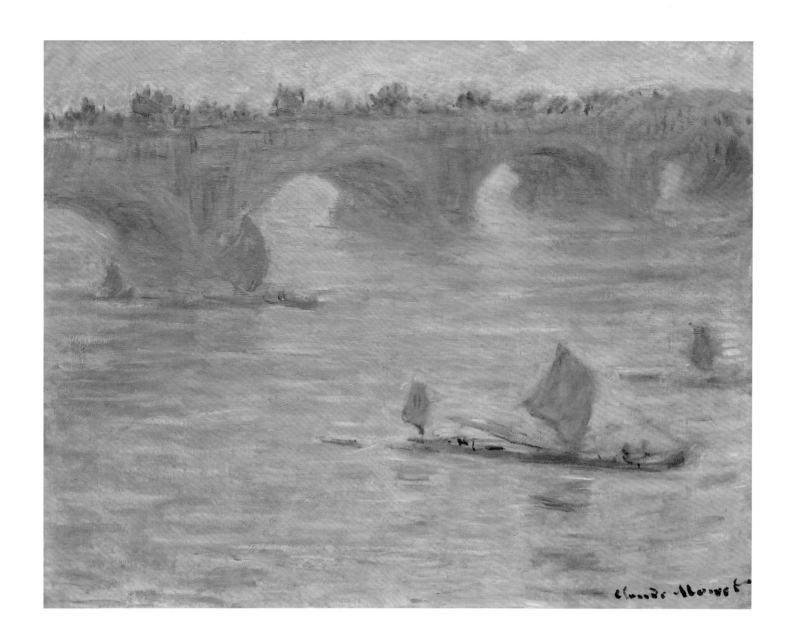

Fig. 20. *Waterloo Bridge*, 26 x 32 inches (66 x 81.3 cm), Lowe Art Museum,
University of Miami, gift of Ione T. Staley. Cat. no. 15.

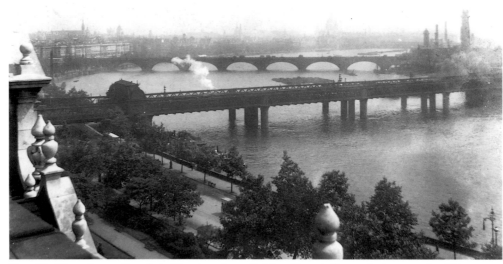

Fig. 21. *Westminster, London, Charing Cross Bridge*, Royal Commission on the Historical Monuments of England. The Victoria Embankment with its gardens and Charing Cross and Waterloo Bridges.

for working because, as he wrote, "with all my stuff I could never have turned around" (w. 1504). This comment suggests that he already had many paintings under way.

In addition to Waterloo Bridge and Charing Cross Bridge Monet decided in 1900 to introduce a new motif, that of the Houses of Parliament (fig. 22). Their towers had appeared in one of Monet's early views of the Thames from 1871 (fig. 5) and can be seen in the distance in many of the Charing Cross paintings (fig. 14). Through his English contacts—Sargent's friend Mrs. Hunter was helpful—he got permission to paint in St. Thomas's Hospital, which was directly across the river (fig. 23). There was a big reception room where he could leave his things (the paintings were locked in a crate), but he wanted to paint out of doors or at least on a covered terrace (w. 1505). He began some sketches [*croquis*] there on February 13 (w. 1506).

He described his routine in a letter to Alice of February 1900:

> My life is usually very calm and regular, working all day, almost always lunching and dining in the grill room downstairs. The rest of the time is for correspondence and to spread out my canvases which I look at up till the moment when I go to sleep, but now that the weather is more possible, I am going to get into the habit of walking on leaving the hospital. I feel fine and sleep like a log until 6:30 when I get up. (w. 1516)

During most of the day he worked in his hotel room, where he sometimes had

Fig. 22. *Houses of Parliament*, photograph from same angle as Monet's paintings.

his lunch brought when the weather was particularly changeable. He left in the late afternoon for St. Thomas's Hospital, where he painted the Houses of Parliament as the sun set. He sometimes had lunch with his son or dined out in the evening with the expatriate American painter John Singer Sargent and other English acquaintances.

Although he had contact with Londoners, Monet approached London as an outsider, and he painted London with a tourist's detachment rather than an inhabitant's familiarity. He knew very little English. When his son Michel, who was supposed to serve as his interpreter in making arrangements to paint at St. Thomas's Hospital, went skating instead, Monet wrote, "I managed as best I could, with this gentleman not speaking French; no doubt he will come to dinner" (w. 1505). His routine of painting in a hotel meant that he was removed from ordinary life in London. His view from a high window showing the bridges or the Houses of Parliament cut off, without means of access, emphasized this detachment.

Although his subject matter hinted only obliquely at the activities of the modern city, Monet's letters show that he was engaged to some extent with con-

30

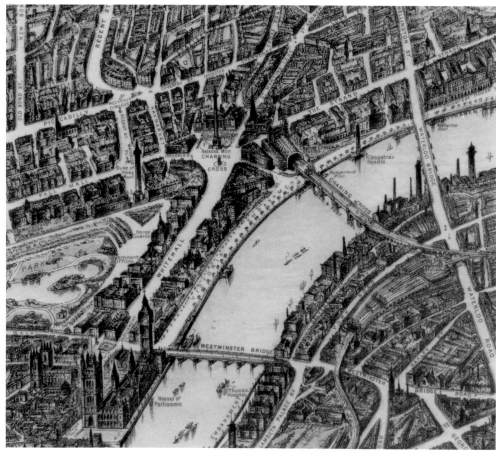

Fig. 23. *ABC Pictorial Map of London* (detail), London: Charles Bell & Co., 1892, Corporation of London, Guildhall Library.

temporary issues. He discussed the Boer War when he dined out, showing a typical continental opposition to the British policy. He also mentioned ways in which the war affected London in a letter of February 15, 1900.

> As to the war, it becomes more and more terrible and heroic on the part of the Boers; people thought they were done for, but they aren't giving up and, on the contrary, seem disposed to hold their own against the English. It's extraordinary to see London at this moment; you see nothing but volunteers all newly dressed; these are all the young society people who equip and arm themselves at their own expense; every day some leave, and every evening the restaurants are full of them; they are feted and cheered, the poor devils who are going to get themselves killed or die of fatigue; but it's now really chic to enlist, it's altogether "smart." (w. 1518)

The beginning of his visit in 1901 coincided with mourning for Queen Victoria, who had just died. He watched the funeral cortege on February 2 with Henry James, who he said spoke admirable French and was extremely charming; James explained everything, and showed him the personalities of the court. Monet described the event colorfully, but showed no inclination to paint it (w. 1592).

Although he saw Sargent and his friends frequently, and met important people through them,[19] he felt a sense of reserve. He wrote to Alice in February 1901 that he had had dinner with George Moore (an Irish critic who had spent time in Paris) and had enjoyed chatting with him.

> At Mrs. Hunter's dinners, it's always the conversation of society people, even though she couldn't be nicer and less affected, but it's only a distraction. It's the same way with Sargent, there's not a complete enough agreement on the way of seeing for me to find a complete pleasure with him. (w. 1601)

These outside events and social contacts were distractions. The focus of his activities and his letters was always his painting. He informed his correspondents about the number of canvases he had begun: forty-four on March 1, 1900; fifty on March 4; something like sixty-five on March 18; and at the end of March he said he would be returning with a total of eighty.[20] He came back to Giverny, exhausted, around April 7 (w. 1549).

When he returned to London on January 25, 1901, his crates of paintings were held up by customs (w. 1587). While he waited for them, he made sketches with pastels (w. 1589, w. 1590, fig. 51).

Monet began his last period of painting in London by restricting the number of canvases he had out:

> Besides the hospital, I work steadily at my window and I made a good decision, which is to only occupy myself with one of my motifs and, when I'm more or less finished with it, I will go to another. Since I have been here, besides the pastels, I have only worked on Waterloo Bridge, about ten canvases. In this way I have a smaller number of canvases to look over, and it's going better, but I will be very glad when I have some almost done. (w. 1595)

He was still working on the Waterloo Bridge paintings on February 21, and complained about how long it was taking him and how much trouble he had (w. 1608b). His letters do not mention that he had switched to the Charing Cross paintings; however, they make it clear that his plans for working in an orderly fashion were impractical in such changeable conditions. In March he wrote that he couldn't dream of working on the same things two days in a row, and was having to do sketches and notations to work out tranquilly in the studio (w. 1611).

With the assistance of Sargent, he made arrangements to paint some urban

Fig. 24. John Singer Sargent, *Henry James*, 1912, National Portrait Gallery, London.

31

19. The two artists had met around 1876 in Paris and had worked together in the later 1880s at Giverny. The first biographer of Sargent, Evan Charteris, *John Sargent* (New York: Charles Scribner's Sons, 1927) had visited Monet; the most recent, Stanley Olson, *John Singer Sargent: His Portrait* (New York: St. Martin's Press, 1986), discusses Sargent's social contacts, but does not use the Monet letters. Letters w. 1503, 1504, 1519, 1520, 1523, 1525, 1534, 1536, 1593, 1601, 1603, 1606a document Monet's contacts with Sargent and his friends while he was in England. Some of these occasions included such people as the head of the British Museum, the Secretary of War, the Asquiths, and a countess (perhaps Princess Louise) who did sculpture.
20. w. 1521, to Alice Monet, London, 1 March 1900; w. 1522, to Blanche Hoschedé-Monet, London, 4 March 1900; w. 1532, to Alice Monet, London, 18 March 1900; w. 1543, to Alice Monet, London [28 March 1900].

Fig. 25. *Leicester Square, La Nuit*, 31½ x 25¼ inches
(80 x 64.1 cm), private collection.

21. Wildenstein reports that the Club was the
Green Room, on the corner of St. Martin's
Street, and that Monet painted the square
and the illuminated Empire Theatre from
the first floor (W. 1615-17).

night scenes from the window of a club overlooking Leicester Square.[21] He
began them in early March. Three of these sketches survive (fig. 25). His letters
suggest that they were done to amuse himself, initially at least, and the end of
his stay cut short any extended development that might have emerged from
the group. His illness during the last two weeks of March prevented him from
carrying his Thames paintings further, and he ended his last stay in London
very discouraged. On April 8 he wrote Durand-Ruel that he had been back in
France for a few days and had not yet unpacked his crates (w. 1630).

Monet did not return to London, but continued to work on the London
paintings in his studio to finish them and to prepare them for the exhibition,
which finally took place in May and June of 1904.

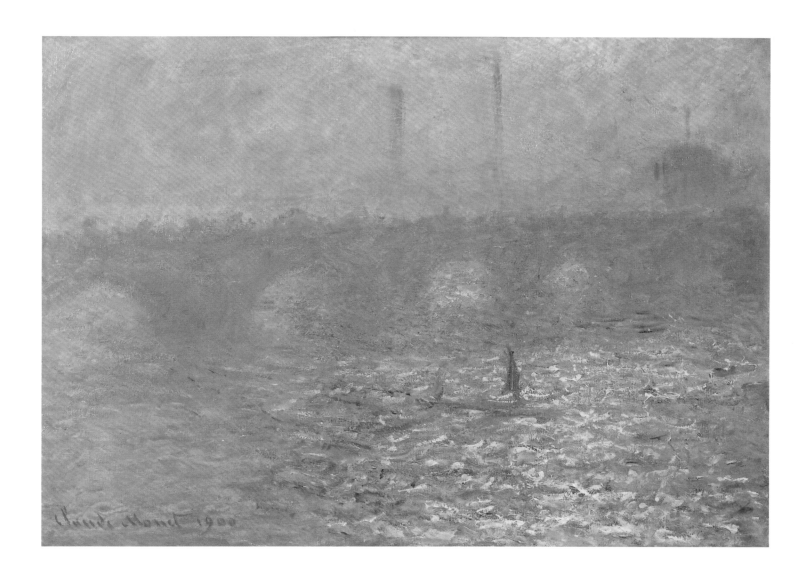

Fig. 26. *Waterloo Bridge*, 25¾ x 36½ inches (65.4 x 92.7 cm), Santa Barbara
Museum of Art, bequest of Katherine Dexter McCormick in memory of her
husband, Stanley McCormick. Cat. no. 6.

Monet & London

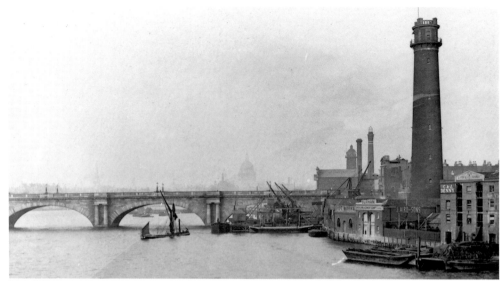

Fig. 27. *Waterloo Bridge, South Bank*, 1890, photograph, Greater London Record Office and History Library. High tide.

22. Kate Flint, *Impressionists in England: The Critical Reception* (London, Boston, Melbourne and Henley: Routledge & Kegan Paul, 1984), p. 2. Monet's *Entrance to Trouville Harbour* and Pissarro's *A Snow Effect, Upper Norwood* were among the heterogeneous French paintings from Ingres to the Barbizons shown in Durand-Ruel's exhibition in December 1870 at 168 New Bond Street. They were not mentioned in criticism.

23. Ibid., pp. 5, 6, and appendix. There are no records of work exhibited 1875-80. In 1883 the Impressionists came to the attention of the London public with an exhibition organized by Durand-Ruel in which seven works by Monet were shown. Monet showed in a group show in 1889. In 1891 his works appeared in three group shows: the New English Art Club, the Goupil Gallery, and La Société des Beaux-Arts. In 1892 his works appeared in an exhibition of Coquelin's collection with some recent works at the New English Art Club. He didn't show again until a few paintings appeared in group shows in 1898 and 1899. During the period when he was working in London, he did not show many works in England.

London was a challenge for an artist who worked directly from nature. It was a man-made motif, and one that had been depicted many times in different media. Monet's own experience, and the visual and literary images that had preceded him, shaped his approach. His indeterminate, detached, atmospheric view of the foggy river was in line with *fin-de-siècle* sensibilities. It was also in accord with Monet's tendency in his later art to distance himself from his motifs and from immediate decisions about the paintings.

Monet had been attracted by London's atmosphere in 1870, but his choice of this motif for his later paintings may have been motivated by career ambitions as well. His first stay was for non-artistic reasons, and its remembered unhappiness, as well as its association with the first showing of his work there by Durand-Ruel in 1870,[22] may have motivated Monet's wish to return as a successful artist. His plans to paint the Thames in the 1880s involved promoting his career. In 1880 Monet was corresponding with the critic Théodore Duret on strategies for finding buyers. Monet wrote that if he were certain of making some sales, he would try to come to London while Duret was there: ". . . when you come through Paris, you can advise me on what the chances could be for me in coming to spend several weeks in London where I could paint some aspects of the Thames" (w. 203, w. 204).

Although Monet did not go to London in the early 1880s, he did send works there. He showed a variety of works in group shows in the 1880s and 1890s.[23]

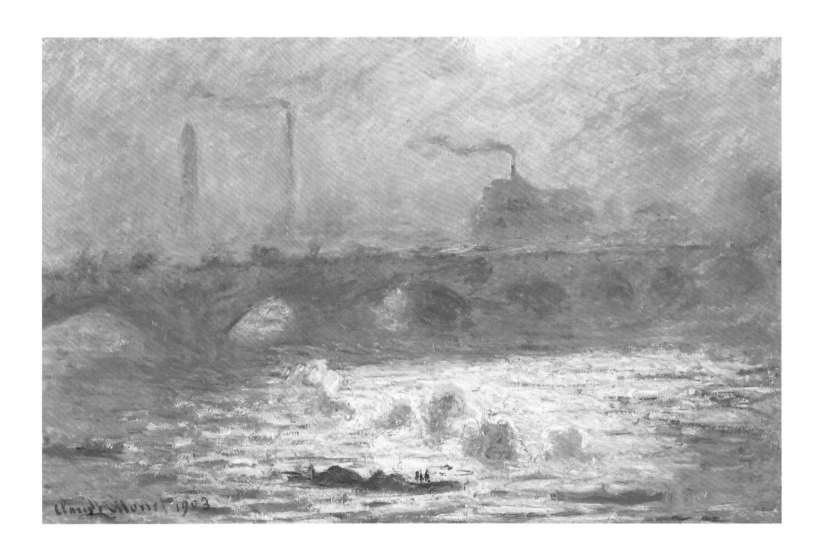

Fig. 28. *Waterloo Bridge* [*Effet de soleil*], 25½ x 39 inches (64.8 x 99 cm), Denver Art
Museum. Cat. no. 10.

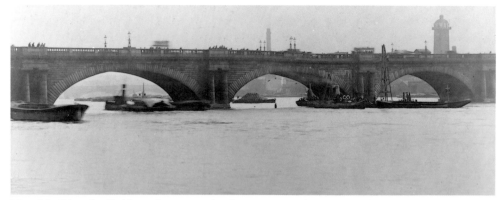

Fig. 29. *Waterloo Bridge*, photograph, Greater London Record Office and History Library. High tide.

24. Ibid., p. 8. The regular showing in official venues dated from 1887. In December 1887 Monet's *Coast of Belle Isle, Bretagne, Meadow of Limetz, Village of Bennecourt,* and *Cliff near Dieppe* were each £160; out of 543 paintings, only two paintings by Grace and one by Alfred Stevens were more expensive.

25. On the exhibitions in 1893 see letters w. 1194 and w. 1197. Mrs. Charles Hunter, Sargent's friend and patron, was one potential contact. Letter w. 1593, 3 February 1901, speaks of an invitation to the Wertheimers'.

26. When Monet was on the committee for the Exposition internationale at Galerie Georges Petit in 1887, Whistler was invited to show. Letters w. 778, w. 779, w. 783, w. 788.

27. John House, "The Impressionist Vision of London," *Victorian Artists and the City: A Collection of Critical Essays,* ed. Ira Bruce Nadel and F.S. Schwarzbach (New York, Oxford, etc.: Pergamon Press, n.d.), pp. 78ff., discusses Whistler's importance in this respect. See also Allen Staley et al., *From Realism to Symbolism: Whistler and His World,* exhibition catalogue (New York: Wildenstein and Philadelphia Museum of Art, 1971).

While the formal innovations and non-narrative subjects of the Impressionists were outside of mainstream British taste, some critics responded favorably. If Monet was interested in finding British patrons, however, he was disappointed. According to Kate Flint, although Impressionist works were seen regularly in London from the 1880s on, very few seem to have been sold to British collectors. This may have been in part because their prices were higher than those of most works by British artists.[24]

The successful portrait painter Sargent, who urged Monet to show in London in the early 1890s, may have encouraged the artist's professional interest in London. He was very much in evidence when Monet was in London and assisted him in making arrangements, dined with him, and provided social contacts—some of whom may have been intended as potential patrons.[25]

Monet's interest in showing and painting in London was certainly stimulated by his renewed contact with another American expatriate, James McNeill Whistler, whom he had known in France in the 1860s. Duret, who was a friend of both men, may have been an intermediary. Whistler had begun showing again in Paris in 1882, sometimes in group shows with Monet.[26] In 1887 Whistler, as president of the Society of British Artists, presented an exhibition which he intended to be revolutionary, and Monet was invited to participate. Monet went to visit Whistler in August and wrote to Duret:

> Did you know that I went to London to see Whistler and that I spent about twelve days there, very impressed by London and also by Whistler, who is a great artist; moreover, he could not have been more charming to me. (w. 794)

Whistler, more than any other person, was responsible for the tradition of atmospheric paintings of the Thames.[27] Whistler's Nocturnes (fig. 68) and

prints may have rekindled Monet's interest in painting London. He wrote that he planned to go to London for the opening in November: "I would even like to try to paint some effects of fog on the Thames there" (w. 797, w. 798).

No London views survive from this time, although Monet continued to think about painting there. He wrote about it in 1891,[28] and Pissarro reported that he had gone there: "Monet has been in London since yesterday. He probably went there to work. Everyone is awaiting with impatience his series of London impressions."[29] But Monet wrote to Mirbeau in February 1892 that finishing up paintings would no doubt keep him from realizing his plan of going to London (w. 1130).

During this long period of gestation Monet must have thought about what he might do with his London paintings. He could have had an image of the city in his mind, not only from his early work there, but also from the literary idea of the city and pictures of it. There was an extensive British tradition of topographic painting that included views of the Thames.[30] These precise renderings of buildings and geographic features in paintings and prints did not appeal to Monet. He later said to Gimpel, "How could the English painters of the 19th century paint houses brick by brick? These people painted bricks that they didn't see, that they couldn't see."[31]

During the 1890s both Monet and Pissarro reapproached the city as an Impressionist subject, finding ways of noting their perceptions rather than documenting in a topographical way. Monet had painted Rouen Cathedral in the early 1890s. Pissarro painted views of the harbor at Rouen under different conditions in 1896. The subject matter of paintings like *Le Pont Boieldieu à Rouen, temps mouillé* (*Boieldieu Bridge, Misty Weather*), 1896 (fig. 30), was as different from Pissarro's rural scenes as London was from Monet's usual landscapes. Characteristically, Pissarro took an interest in the workers and the industrial aspect of the place, whereas Monet showed little evidence of contemporary activities. Pissarro's paintings were so successful that Durand-Ruel financed a return trip to Rouen.[32] Pissarro continued his urban subjects until his death, painting Parisian boulevards from a window.

The vision of London and the Thames that attracted Monet was an atmospheric one—modern, but seemingly timeless. The London paintings are not realist in the sense of giving an insight into the reality of past ways of life; they did not acknowledge the industrial or political aspects of the city except in their material manifestations. Instead they show a series of subjective responses to a real place at apparently very particular times.

This point of view had literary as well as visual sources. In the early part of the century works in the topographical tradition, in revealing the splendor of the buildings and river, suggested a confident and optimistic point of view.[33]

Fig. 30. Camille Pissarro, *Le Pont Boieldieu a Rouen, temps mouille*, 1896, 29 x 36 inches (73.7 x 91.4 cm), Art Gallery of Ontario, Toronto, gift of Reuben Wells Leonard Estate.

37

28. w. 1126, to P. Durand-Ruel, Giverny, 25 December 91. He wrote that he was going to work in London if the winter wasn't good.
29. Pissarro, *Letters*, p. 238, Paris, December 9 1891. He had heard the news from Joyant, of Boussod and Valadon. M. Harvley, with whom Monet was supposed to be staying, is not mentioned in Monet's London correspondence. See note 17.
30. For views of London see David Piper, *Artists' London* (New York: Oxford University Press, 1982).
31. René Gimpel, *Diary of an Art Dealer*, trans. John Rosenberg (New York: Farrar, Straus, and Giroux, 1966), p. 73 [my translation].
32. Ralph E. Shikes and Paula Harper, *Pissarro: His Life and Work* (New York: Horizon Press, 1980), pp. 293-95.
33. See Donald J. Gray, "Views and Sketches of London in the Nineteenth Century," *Victorian Artists and the City*, pp. 43-57.

Wordsworth's "Composed upon Westminster Bridge, September 3, 1802" compares the beauty of the city to that of nature.

> Earth has not anything to show more fair:
> Dull would he be of soul who could pass by
> A sight so touching in its majesty:
> This City now doth, like a garment, wear
> The beauty of the morning; silent, bare,
> Ships, towers, domes, theatres, and temples lie
> Open unto the fields, and to the sky;
> All bright and glittering in the smokeless air.
> Never did sun more beautifully steep
> In his first splendor, valley, rock, or hill;
> Ne'er saw I, never felt, a calm so deep!
> The river glideth at his own sweet will:
> Dear God! the very houses seem asleep;
> And all that mighty heart is lying still!

Significantly, Wordsworth's is a view of the Thames on a Sunday, "all bright and glittering in the smokeless air," while Monet was bored by English Sundays and lamented their lack of smoke and activity (w. 1616).

Later representations of the city, like those in the novels of Dickens, reflected the complexities of modern urban life and the dislocations as well as the smoke of the Industrial Revolution. Monet rejected this literary direction, which had its counterpart in illustration in works by artists like Gustave Doré who presented a dark and claustrophobic view.[34] A Dickensian London of slums and buildings, of markets and street life, appeared occasionally during the 1880s in the pages of *La Vie Moderne*, a modish French periodical. Monet chose instead to show a city whose population was indicated only by the movements of vehicles and the smoke of industrial activities.

His personal response had parallels in French literature. For some writers the fog and the essence of the city seemed intertwined. Des Esseintes, the decadent hero of Huysmans' *Against the Grain* (*A Rebours*), written in 1884, travelled to England vicariously, in his imagination. Although he was inspired by Dickens and had an interest in English types, the Thames and the atmosphere of London also played a part in his reverie.

> A rainy, colossal London smelling of molten metal and of soot, ceaselessly steaming and smoking in the fog now spread out before his eyes. . . . All this was transpiring in vast warehouses along the river banks which were bathed by the muddy and dull water of an imaginary Thames, . . . while trains rushed past at full speed or rumbled underground uttering horrible cries and vomiting waves of smoke, and while, through every street, monstrous and gaudy and infamous advertisements flared through the eternal twilight. . . . Des Esseintes shivered deliciously to feel himself mingling in this terrible world of merchants, this insinuating mist, in this incessant activity. . . .[35]

34. See Ira Bruce Nadel, "Gustave Doré: English Art and London Life," *Victorian Artists and the City*, pp. 152-62.
35. J. K. Huysmans, *Against the Grain*, trans. John Howard (New York: Albert and Charles Boni, 1930), pp. 190-93.

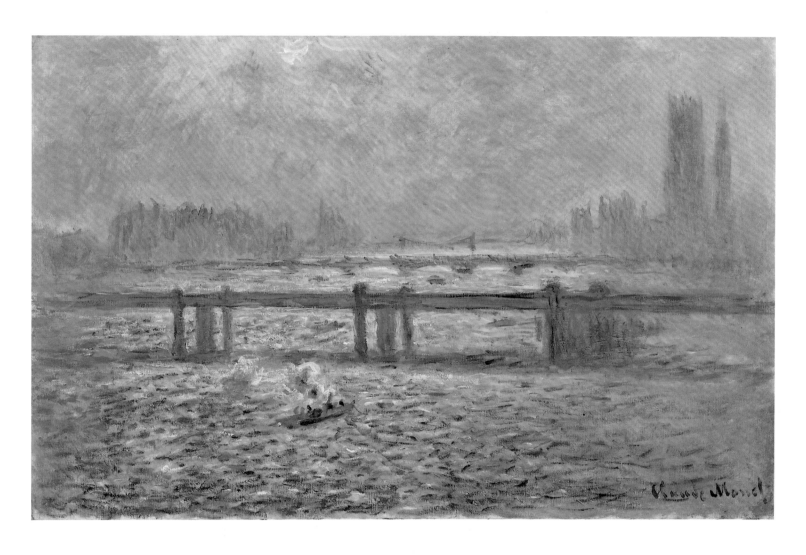

39

Fig. 31. *Charing Cross Bridge* [*Reflets sur la Tamise*], 24½ x 39½ inches (62.2 x 100.3 cm), The Baltimore Museum of Art, The Helen and Abram Eisenberg Collection. Cat. no. 4.

40

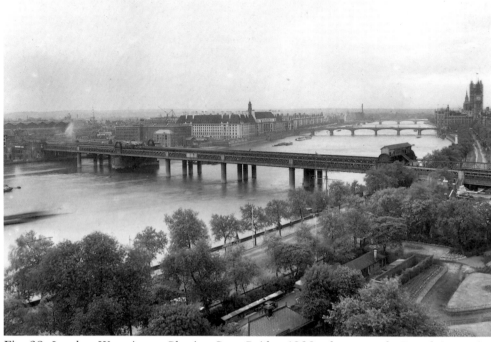

Fig. 32. *London, Westminster, Charing Cross Bridge*, 1938, photograph, Royal Commission on the Historical Monuments of England. St Thomas's Hospital, from which Monet painted the Houses of Parliament, is beyond Westminster Bridge on the left. The large building on the left was built after Monet painted.

Hippolyte Taine, a French visitor to London in the 1860s, saw the city and its fog in ways that were close to Monet's.

Ships coming, going, waiting . . . at moorings, in among the chimneys of houses and the cranes of warehouses. . . . They are enveloped in a fog of smoke irradiated by light. The sun turns it to golden rain and the water, opaque, shot with yellow, green and purple, gleams and glitters as its surface lifts and falls, with strange and brilliant lights. The atmosphere seems like the heavy, steamy air of a great hot-house. Nothing here is natural: everything is transformed, violently changed, from the earth and man himself, to the very light and air. But the hugeness of this accumulation of man-made things takes off the attention from this deformity and this artifice; in default of a wholesome and noble beauty, there is life, teeming and grandiose. The gleam of brown river water, the diffusion of light trapped in vapour, the white and rosy luminosity playing over all these colossal objects, spreads a kind of grace over the monstrous city—like a smile on the face of some dark and bristling Cyclops.[36]

36. Hippolyte Taine, *Notes on England*, trans. Edward Hyams (Fair Lawn, N.J.: Essential Books, 1958), p. 8.

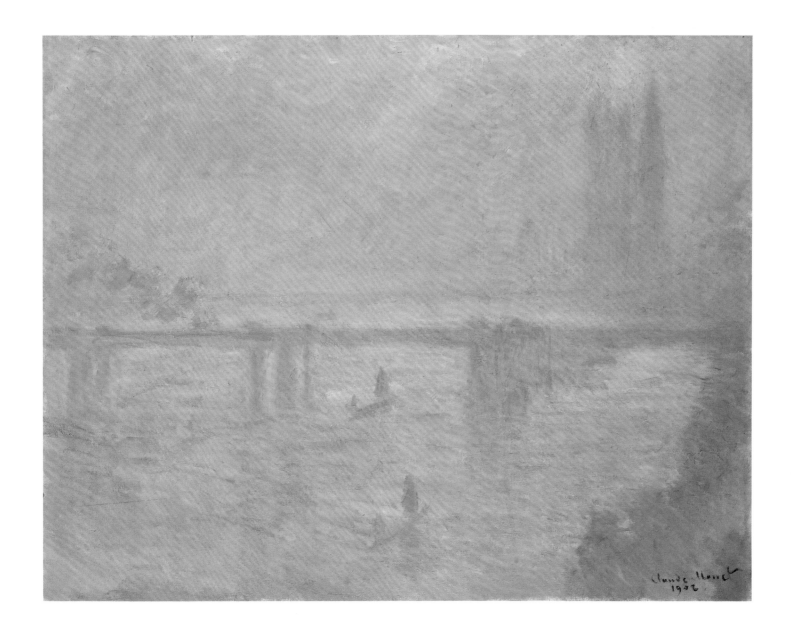

Fig. 33. *Charing Cross Bridge*, 25⅝ x 33⅞ inches (65.2 x 81 cm), National Museum of Wales, Cardiff.

37. Quoted in Piper, *Artists' London*, p. 8.
38. This is especially true of early English writers on Impressionism who wished to link its discoveries with those of English artists. See Flint, *Impressionists in England*, pp. 25ff., 189-92 and Bowness, *The Impressionists in London*, pp. 14-16.
39. Pissarro, *Letters*, p. 26. A letter from Lucien to Pissarro (London, 11 July 1883) reveals that Lucien was studying Turner's works; he especially admired *Rain, Steam, and Speed*. Pissarro advised him to study Turner's wash drawings (Osny, 25 July 1883) p. 29.
40. In writing to his son about the Dewhurst book, Pissarro was indignant, and insisted upon the *French* sources of their style. To Lucien, Paris, May 8, 1905, ibid., pp. 470-71.
41. Monet had known Whistler in the 1860s, but there is no evidence that he saw him in London in 1870-71. However, he may have seen some of Whistler's works at that time. *From Realism to Symbolism: Whistler and his World* (nos. 105, 106) discusses Monet and Whistler. The catalogue and the essay by Allen Staley, "Whistler and his World," are helpful in assessing Whistler's role.
42. Theodore Robinson, Diary, September 1892, quoted in John Gage, *Turner: Rain Steam and Speed* (New York: Viking Press, 1972), p. 75.
43. Ibid., pp. 67-75 discusses the connection between Turner's work and that of the Impressionists. He concludes that while Monet's early works do not show direct links with Turner's, the London works show similarities. He quotes Gustave Kahn's review (see below). House, *Monet: Nature into Art*, p. 222, proposes that it was Monet's search for an overall colored unity that accounted for his renewed interest in Turner: "The 'tinted steam, so evanescent and so airy' of Turner's later work must have shown him the potential of the sunlit envelope as a vehicle for this unity."
44. Gimpel, *Diary of an Art Dealer*, p. 73.

42

Fog naturalized the urban and industrial context and made it beautiful. It also became part of a conventional way of viewing the city. In the 1880s Oscar Wilde commented on the relation of such views to previous artistic expressions.

> At present, people see fogs, not because there are fogs, but because poets and painters have taught them the mysterious loveliness of such effects. There may have been fogs for centuries in London. I daresay there were. But no one saw them, and so we did not know anything about them. They did not exist until Art had invented them.[37]

If they did not provide precise models, previous artists gave Monet examples for depicting London in an atmospheric way. Many writers, including Monet's contemporaries, have suggested that seeing the works of Constable and Turner was a revelation to Monet and Pissarro in 1870-71.[38] Pissarro's letters give mixed evidence on the matter. He told Wynford Dewhurst that he and Monet had studied English artists, and he encouraged his son to study Turner.[39] But he also insisted that they had already been interested in light and had French sources for their work: "It seems to me that Turner, too, looked at the works of Claude Lorrain."[40] It is clear that he, like Monet, considered that Turner was doing something different from what the Impressionists were trying to do. Their works of 1870-71 do not show an immediate influence. Monet's tonal treatment in his paintings of the Thames in 1871 and subsequent works like *Impression, Sunrise* are more in keeping with Whistler's vision than with Turner's.[41]

Nevertheless, if Turner did not immediately provide an example, his work was probably one source of inspiration for Monet's later attempt to make pictures which take on a modern urban subject. Turner's *Rain, Steam and Speed— The Great Western Railway* (1844), which was in the National Gallery (fig. 34), showed elements that appeared in the Thames paintings: a train and bridges seen in a dense, colored atmosphere. In 1892 Monet had spoken admiringly of Turner to the American painter Theodore Robinson, referring to "the railway one—and many of the watercolor studies from nature."[42] The later London paintings, with their extraordinary effects of atmosphere and light, are among the works of Monet most reminiscent of Turner's, as critics at the time commented.[43]

The dealer Gimpel, in his journal for 1918, reported a conversation with Monet in which he tried to find out, without much success, what earlier painters had inspired the artist. Monet only said that the School of 1830 had been influenced by Constable and Turner. He added, "Formerly I liked Turner very much, today I like him much less—why?—he didn't organize the color enough and he used too much of it; I studied him well."[44] It may have

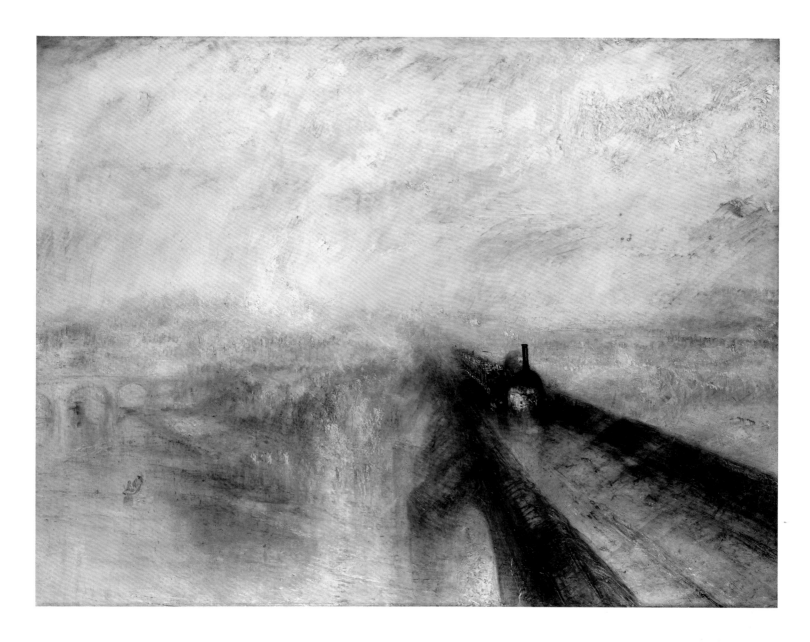

Fig. 34. Joseph Mallord William Turner, *Rain, Steam and Speed—The Great Western Railway*, 1844, 35¾ x 48 inches (90.8 x 121.9 cm), The National Gallery, London

Fig. 35. James McNeill Whistler, *The Savoy Pigeons* from *Homes of the Passing Show*, p. 28, a drawing made by Whistler from the terrace of his sitting room while staying at the Savoy Hotel.

44

45. James McNeill Whistler, "Ten O'Clock" [1885], reprinted in Denys Sutton, *James McNeill Whistler: Paintings, Etchings, Pastels & Watercolours* (London: Phaidon, 1966), p. 53.

46. Views of London, taken around 1904, were published in Alvin Langdon Coburn, *London*, introduction by Hilaire Belloc (London: Duckworth & Co., [1909]). On Coburn see Mike Weaver, *Alvin Langdon Coburn: Symbolist Photographer 1882-1966: Beyond the Craft* (Millerton, N.Y.: Aperture, 1986). He states (p. 57) that the Impressionist emphasis on the atmospheric treatment was not enough for Coburn, who was interested in a more essential or symbolic expression.

47. Quoted in Roy McMullen, *Victorian Outsider: A Biography of J.A.M. Whistler* (New York: E. P. Dutton & Co., 1973), p. 249. See pp. 245-54 for a discussion of Whistler in Paris and his connections with *fin-de-siècle* sensibility.

been Monet's efforts to give form to his sketches that made him feel Turner's limitations.

In the "Ten O'Clock" lecture Whistler described the kind of tonal and atmospheric effects he presented in his paintings and prints (figs. 35, 68):

> And when the evening mist clothes the riverside with poetry as with a veil, and the poor buildings lose themselves in the dim sky, and the tall chimneys become campanili, and the warehouses are palaces in the night, and the whole city hangs in the heavens, and fairy-land is before us. . . . Nature, who, for once has sung in tune, sings her exquisite song to the artist alone. . . .[45]

Whistler viewed the Thames, as he did his other subjects, as providing the elements for art, but it was up to the artist to combine them in a harmonious way. His insistence on art for art's sake became a part of the aesthetic approach to the Thames.

Not only artists, including etchers, but also photographers, such as Alvin Langdon Coburn (like Whistler an expatriate American), saw the foggy Thames, its bridges, and its shipping as a source of aesthetic inspiration. Photographing in the years that Monet was working on his series, Coburn made photographs of many of the same subjects (figs. 39, 42), emphasizing their atmospheric and tonal qualities by his choice of lens and type of print.[46] Like Whistler, Coburn was inspired by the radical cropping of Japanese prints. Monet, who had absorbed these lessons earlier, also cropped and floated his bridges as flattened shapes. Coburn and other Pictorialist photographers owed much to Whistler in their vision of photography as art.

Although Whistler was not painting landscapes at the time Monet visited him, Monet saw the paintings he had on hand, which included unsold landscapes. In encouraging Whistler to prepare a good exhibition he wrote in 1888, "You have enough wonderful things in your studio" (w. 853). Whistler may have encouraged Monet to paint the Thames; he may even have suggested the Savoy Hotel, where he and his wife stayed in 1896-97, and from which he made some lithographs (fig. 35).

But Whistler and Whistler's indefinite, suggestive paintings had a currency in France in the 1890s that went beyond their subjects. He became a kind of cult figure in France, where he lived during the early part of the 1890s, and was much admired in literary circles. Monet had brought Whistler and Mallarmé (who translated the "Ten O'Clock") together (w. 803), and the two men became good friends. Huysmans wrote in 1889: "M. Whistler, in his harmonies of nuances, practically crosses the frontier of painting: he enters the land of literature, and advances along the melancholy shores where grow the pale flowers of M. Verlaine."[47]

Monet was friends with a number of Symbolist writers, and was certainly

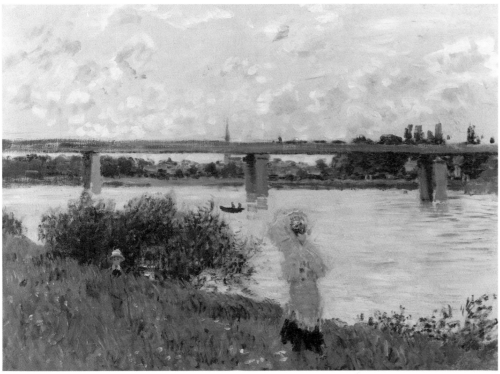

Fig. 36. *The Railroad Bridge at Argenteuil*, 1875-1877, 21³/₈ x 28¹/₂ inches
(54.3 x 72.4 cm), The Saint Louis Art Museum, gift of Sidney M. Shoenberg.

aware of literary currents; however, the question of the extent of his involvement with these ideas is a complicated one. His works of the 1890s, like the London paintings, were vaguer and more suggestive than his earlier works had been. Whistler's landscapes, which did not "name" their objects, in the Mallarméan sense of the word, perhaps provided an impetus for the more evocative direction in Monet's work.

At Argenteuil in the 1870s Monet had painted a railway bridge and a road bridge in a way that acknowledged commerce and leisure in the life of the suburbs (fig. 36).[48] His wife and child appear in the accessible foreground. His more distant view of London was in keeping with the remoteness of his later works.[49] In the Thames paintings, the apparently timeless city was shown suspended in a dense and nearly obliterating atmosphere.[50]

In fact, Monet's London was a nineteenth-century city. The parts of it that interested him were recently built, and all the components of his scene were modern, including the boats he showed on the Thames which were part of its

48. For a discussion of Monet's bridges at Argenteuil see Paul Tucker, *Monet at Argenteuil* (New Haven and London: Yale University Press, 1982), pp. 57-87.
49. Robert Herbert, "Method and Meaning in Monet," *Art in America* 67 (September 1979): 104-05, points out that Monet's sociable motifs of the 1860s and 1870s shift toward images of loneliness and of nature's sublime powers.
50. One of the reviewers commented on the timeless aspect and saw new buildings as old. Charles Morice, "Art moderne: Vues de la Tamise à Londres par Claude Monet," *Mercure de France* 50 (June 1904): 796: "It's the action of light on the antique monuments, on the bridges—of yesterday or today —without age, because without style, on the thick waters. . . . caressing with such a timid reflection these enormous mossy crests of the old Palace of the 'Parlote'!"

46

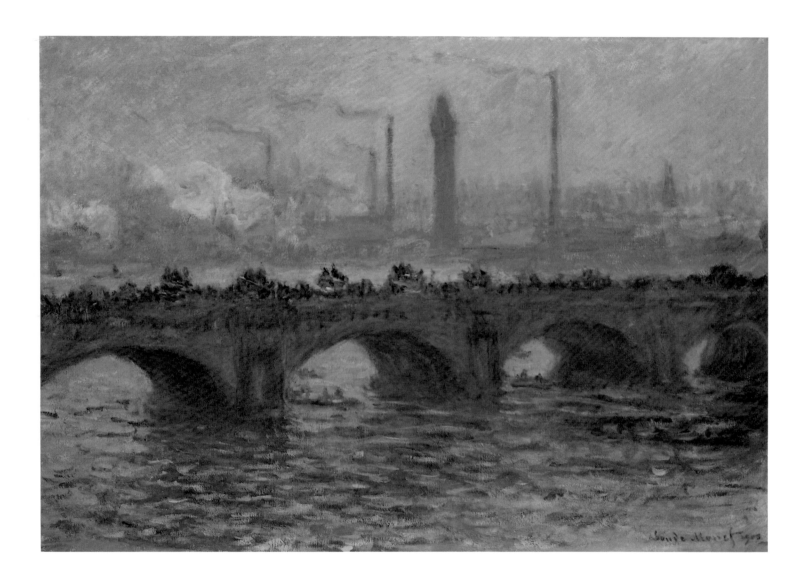

Fig. 37. *Waterloo Bridge*, 25¾ x 36½ inches (65.4 x 92.7), Worcester Art Museum, Worcester, Massachusetts. Cat. no. 13.

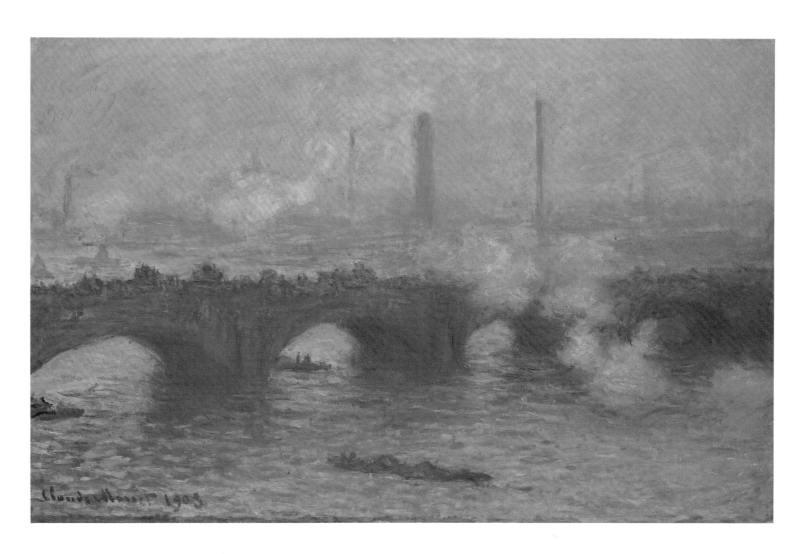

Fig. 38. *Waterloo Bridge, Gray Day*, 25⅜ x 39⅜ inches (64.5 x 100 cm), National
Gallery of Art, Washington, Chester Dale Collection.

Fig. 39. Alvin Langdon Coburn, *Waterloo Bridge*,
ca. 1904, photogravure, 8 x 6⅜ inches
(20.3 x 16.1 cm), International Museum of
Photography at George Eastman House.

51. Karl Baedeker, *London and its Environs: Hand-book for Travellers* (Leipzig: Karl Baedeker, 1911), pp. 73, 126, 203.

52. For general information on these monuments see: Eric de Maré, *London's Riverside: Past, Present and Future* (London: Max Reinhardt, 1958); George Walter Thornburg, *Old and New London*, 6 vols (London, Paris, and New York: Cassell, Peter, Galpin & Co., n.d.); Baedeker, *London and its Environs*; and *The London Encyclopedia*. See also Gavin Stamp, *The Changing Metropolis: Earliest Photographs of London 1819-1879* (Harmondsworth: Penguin Books, 1984).

considerable commercial shipping. Even the Thames itself had been modified by the construction of the Embankments, which reclaimed acres of mud and created public gardens along the bank, and which also modified the flow of the river. Although he didn't treat them as monuments, the structures he painted were described in Baedeker as tourist attractions.[51]

His three subjects, Waterloo Bridge, Charing Cross Bridge, and the Houses of Parliament, as well as the Embankments, were all recent constructions; in fact, the Victoria and Albert Embankments had just been completed when Monet was in London for the first time in 1870. St. Thomas's Hospital, from which Monet painted the Houses of Parliament, opened in 1871, and other features of Monet's pictures and of the part of London along the Thames near the Savoy Hotel were of very recent origin.[52]

Waterloo Bridge, designed by John Rennie for a private company which hoped to finance it with tolls, was opened in 1817 by the Prince Regent. It was not successful as a commercial speculation, and in 1878 it was bought by the Metropolitan Board of Works and opened to the public without tolls. It had nine semi-elliptical arches with paired Doric columns on the piers, topped by an entablature and cornice above which was a balustrade. Canova is reported to have said that it was "the noblest bridge in the world" and that it was "alone worth coming from Rome to London to see."[53] It was torn down in 1934 after many protests, because the foundations were unstable and because it was a traffic bottleneck.

Monet's paintings, particularly those with afternoon light, show the columns, but not the details of the ornament (figs. 12, 58). They also give hints of the movement of traffic—the omnibuses especially. This traffic moved from one social realm to another. The north side of the Thames, where Monet was staying, was elegant with large new buildings. The Victoria Embankment had created a public garden, with rows of plane trees that appear in some of the Charing Cross Bridge paintings (figs. 14, 40). The South Bank, by contrast, had small industry. Wharfs, a shot works with its tower, a cement company, and other firms were at the other end of Waterloo Bridge (fig. 27). The smokestacks and shot tower that appear in Monet's views of this motif contrast with the less industrial aspect of the other two motifs.

Charing Cross Bridge was a quintessentially nineteenth-century form of architecture—a railway bridge—designed by Sir John Hawkshaw. It was built in 1863 to take trains to the new Charing Cross Station, the west-end terminus of the South-Eastern Railway. It carried a great deal of traffic on its three tracks and footbridge. It had nine spans supported by cylinders sunk into the bed of the river and by the piers and abutments of Brunel's Hungerford Footbridge, which it replaced. The wrought-iron latticework of the girders is visible in only a few of Monet's paintings (fig. 59). It too no longer exists in the form Monet knew; it underwent a major overhaul in 1979.

Westminster Bridge, which appears beyond Charing Cross Bridge in some of the less foggy paintings, was a replacement, finished in 1862, of the eighteenth-century bridge from which Wordsworth had written his sonnet in 1802.

The Houses of Parliament, or the New Palace of Westminster, were built after the old building burned in 1834. Sir Charles Barry, assisted by Pugin, designed it in a neo-Gothic style. Its elaborate architectural ornamentation with bays and buttresses and exterior decoration—including statues of the English monarchs from William the Conqueror to Queen Victoria with armorial bearings—is barely hinted at in Monet's paintings. Only the pinnacles of the irregular skyline give an indication of its visual complexity. Monet's

53. Thornburg, *Old and New London*, 3: 292-93. Constable was interested in the theme for a long time, beginning around 1819, and finally exhibited his painting in 1832 (private collection). It is illustrated in Piper, *Artists' London*, p. 79.

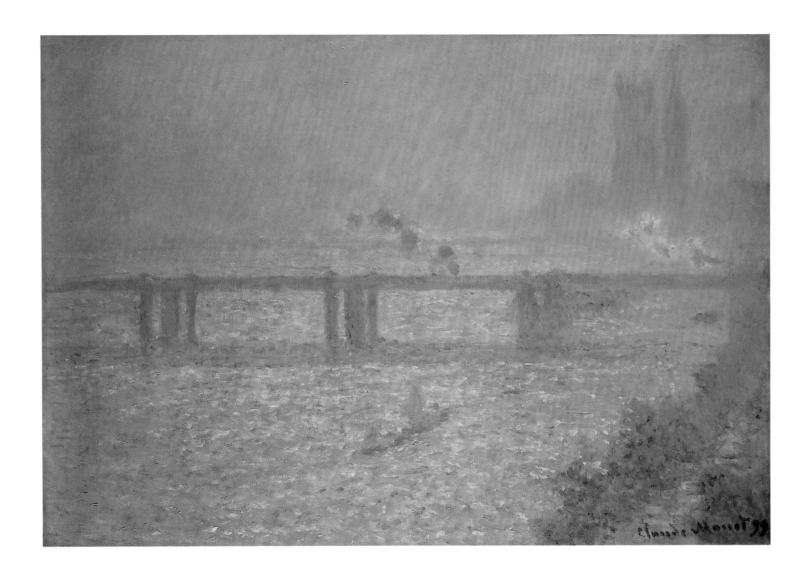

Fig. 40. *Charing Cross Bridge, London*, 25 x 35⅜ inches (63.5 x 89.9 cm), Shelburne Museum, Shelburne, Vermont. Cat. no. 1.

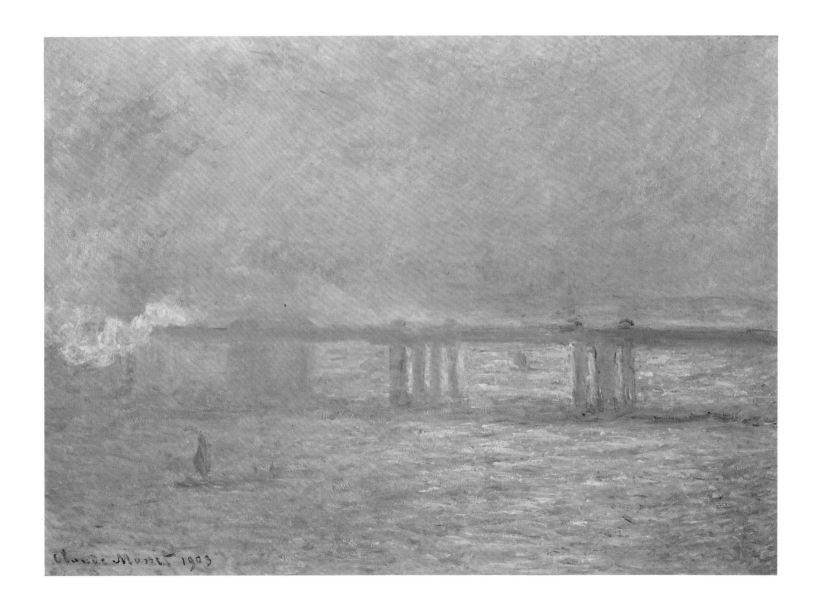

Fig. 41. *Charing Cross Bridge*, 28³/₄ x 39³/₈ inches (73 x 100 cm), The Saint Louis Art Museum. Cat. no. 5.

Fig. 42. Alvin Langdon Coburn, *Houses of Parliament*, ca. 1904, photogravure, 8¼ x 6⅜ inches (20.8 x 16.2 cm), International Museum of Photography at George Eastman House.

paintings all show the largest tower, the square Victoria Tower, on the southwest end of the building, but vary in the extent to which they show the others. They do not show the Clock Tower, famous for Big Ben.

Even the fog was a nineteenth-century phenomenon. Of course London had had fog before; but it was the pollution, mainly caused by the burning of coal by industry and individuals, that gave the atmosphere the peculiar density and color that interested Monet. In the twentieth century, when coal was replaced by other fuels, the smog (to give it a more accurate name) diminished. By the time the Clean Air Act of 1956 banned smoke from the traditional "dirty" coal, the kind of fog Monet saw had already vanished.[54]

Monet's view of London, with its distancing and appreciation of the spectacle, embodies some of the nineteenth-century artists' and writers' ambivalence about the city as a something without fixed identity, in flux and confusion, a nexus of decadence and pollution, but a source of energy and beauty.[55]

54. Piper, *Artists' London*, p. 9.
55. Renée Joy Karp, "Fearful Wonder: Perceptions of Paris and London in Some Nineteenth-Century French and English Novels" (Ph.D. diss. McGill University, 1982), discusses some of these issues.

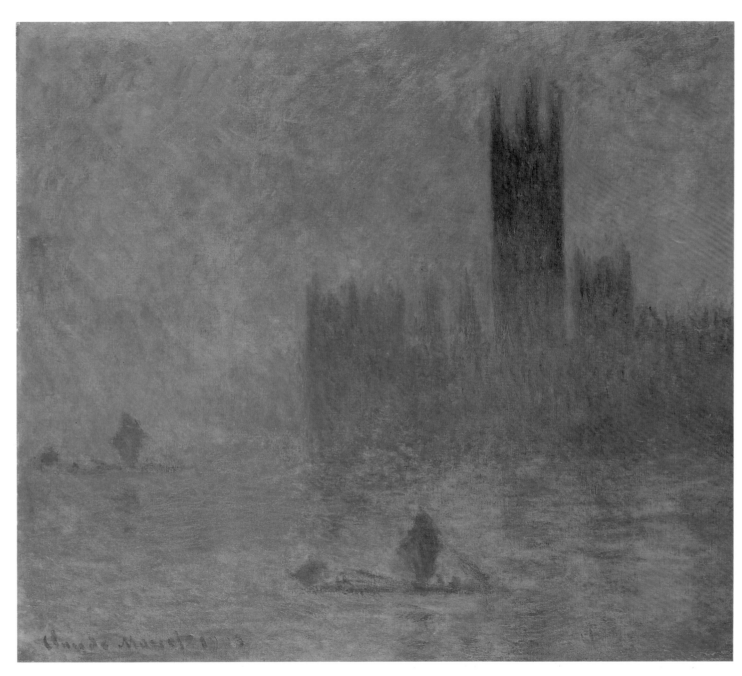

Fig. 43. *Houses of Parliament* [*Effet de brouillard*], 31⅞ x 36¼ inches (81 x 92 cm),
The Metropolitan Museum of Art, bequest of Julia W. Emmons.

At Work in London

The paintings Monet began in London represent an attempt to paint impressions directly from nature, and also to make a group of paintings that had certain qualities he desired. As he wrote to Durand-Ruel in February 1900, "It's so variable, and so difficult! and will I succeed at what I want?" (w. 1510).

He started out confident and made decisions that set up the series to be worked on in an orderly way, but his letters suggest that he felt sabotaged by the weather (although he had been having this problem for twenty years). And succeeding at what he wanted was always ambiguous, because he was constantly re-formulating his ideas.

The process of selection and adjustment had begun with Monet's long period of thinking about the project. When he finally went to London to paint, Monet probably had some kind of image of the Thames in mind. His own early painting (fig. 5), which was then in the Faure collection, and the examples of Whistler, Turner, and other artists, had predisposed him to look for fog. But he was not interested in a tonal rendering; his work from the start dealt with color.

After his first visit in the fall, he had returned to London in the winter, when temperature inversions trapped the smog of coal smoke and industrial pollutants, and when he could be assured of the densest fog. He grew anxious when it seemed to have disappeared; in March 1900 he wrote:

> This morning I believed the weather had totally changed; on getting up I was terrified to see that there was no fog, not even the shadow of a fog; I was devastated and saw all my canvases ruined, but little by little, the fires kindled, and the smoke and fog returned. (w. 1523)

Although Monet's letters talk about snow and rain and other phenomena that he did not show, he was only interested in a relatively narrow range of effects—not too clear or dark or light.

His wish for synthesis, of which he had spoken to Thiébault-Sisson,[56] suggests that part of the work on the series was aimed at finding some essential quality, which was subjective and emotional. His preliminary work at a site helped him to figure out how to approach the subject and what features he would be concentrating on in the series, but his letters show that the process of working on the paintings involved gradually coming to an understanding of what he was doing. He wrote to Durand-Ruel toward the end of his 1900 trip: "I've taken a lot of pains and I believe a third stay will be necessary, it's only that I am beginning to understand . . ." (w. 1538).

His very similar statements to Gimpel in 1918 and 1920 on what he found attractive about London suggest some of the understanding he had come to through making his paintings.

54

56. See above, note 7.

I love London, much more than the English countryside; yes, I adore London, it's a mass, an ensemble, and it's so simple. Then in London, above all what I love is the fog. How could the English painters of the 19th century paint houses brick by brick? These people painted bricks that they didn't see, that they couldn't see.[57]

I so love London! but I love it only in winter. It's nice in summer with its parks, but nothing like it is in winter with the fog, for without the fog London wouldn't be a beautiful city. It's the fog that gives it its magnificent breadth. Those massive, regular blocks become grandiose within that mysterious cloak.[58]

Faced with the complexities of London and the necessity of making rapid notations, Monet had to find a way to give form to his impressions of effects that might or might not return. In his earlier series, such as the Cathedrals, he had chosen simple shapes that provided a structure for the notation of effects and also unified the group. The interconnected forms suggesting the ensemble of London and the breadth of his treatment were expressive and were also practical ways of giving form that was evocative, but not precise.

During his first period of work, he established his point of view for Charing Cross Bridge and almost certainly also for Waterloo Bridge. In seizing a new canvas and rapidly noting an effect, Monet worked with an established relation of some fixed elements. The tops of the bridges were indicated by a nearly horizontal line, usually near the center, without clear points of contact with the banks. He did not adhere to an exactly repeatable formula. In some views of Waterloo Bridge Monet minimized its apparent diagonal recession (fig. 37); in others (fig. 19) it was less spatially ambiguous. In a few he had a markedly higher horizon (fig. 20). The varying placement of the bridges and the differences in their beginnings and endings and in the number of piers or arches showing, as well as the different sizes of the canvases, indicate, even signify, a degree of spontaneity. Even the structures in the background, such as the shot tower and chimneys, were not always in the same relation. As Wildenstein points out, a building with a chimney in its middle, which is on the right edge of some paintings (fig. 26), is in the center in others (figs. 10, 11, 28) and does not appear at all in still others (figs. 37, 38).[59] The fluid elements—the fog, smoke, water, boats, traffic, and, in two pictures, birds (fig. 67)—varied much more. The Thames is a tidal river, but Monet acknowledged this only occasionally in the paintings of Charing Cross Bridge; Waterloo Bridge seems to be shown at high tide (figs. 27, 29, 37).

The different groups within the series have distinctive characters which were undoubtedly sharpened as Monet worked. The rectilinear forms of Charing Cross Bridge contrast with the rhythmic curves of Waterloo Bridge; later Monet added the irregular patterned mass of the Houses of Parliament.

55

Fig. 44. *Monsieur Paul Durand-Ruel*, photograph, Galerie Durand-Ruel, Paris.

57. Gimpel, *Diary of an Art Dealer*, p. 73.
58. Ibid., p. 129.
59. Wildenstein, *Monet*, 4: W. 1565, 1568. An 1872 Ordnance Survey map shows Waterloo Mill (flour) on the east side of Waterloo Bridge.

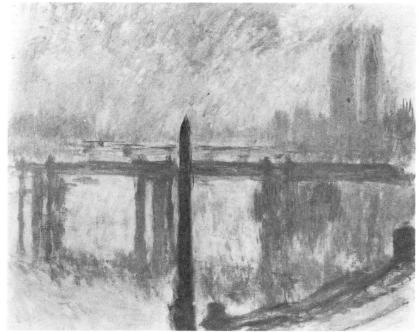

Fig. 45. *Cleopatra's Needle and Charing Cross Bridge*,
25⅝ x 31⅞ inches (65.1 x 81 cm), private collection.

The smoke of the passing trains provided one kind of accent; the traffic on Waterloo Bridge another.

Paintings that were not exhibited, but which Monet kept, reveal the kind of compositional adjustments he considered. Monet could see the Egyptian obelisk called Cleopatra's Needle from the Savoy, but it appears in only two of the surviving works (W. 1543-44, fig. 45). In deciding to eliminate it, Monet may have felt that its strong vertical dominated the picture too much and compromised the space or the sense of the river. Other paintings, such as the Indianapolis *Charing Cross Bridge* (fig. 61), show how Monet considered where to place the bridge and what to do with the Embankment. Joel Isaacson suggests that lowering the bridge in this painting, as Monet considered, would emphasize the thrust into depth in contrast to the rectilinearity of others.[60]

A painting of Charing Cross Bridge left in a very sketchy state (fig. 46) suggests that Monet tried different solutions to the problem of where to begin and end the bridge and how to place it in relation to its surroundings. In a more finished painting with this configuration (fig. 15) he showed the far bank obscured by thick fog, but in most of the Charing Cross paintings he did not

60. Joel Isaacson, "Monet's Views of the Thames," *Bulletin of the Art Association of Indianapolis* 52 (June 1965): 50.

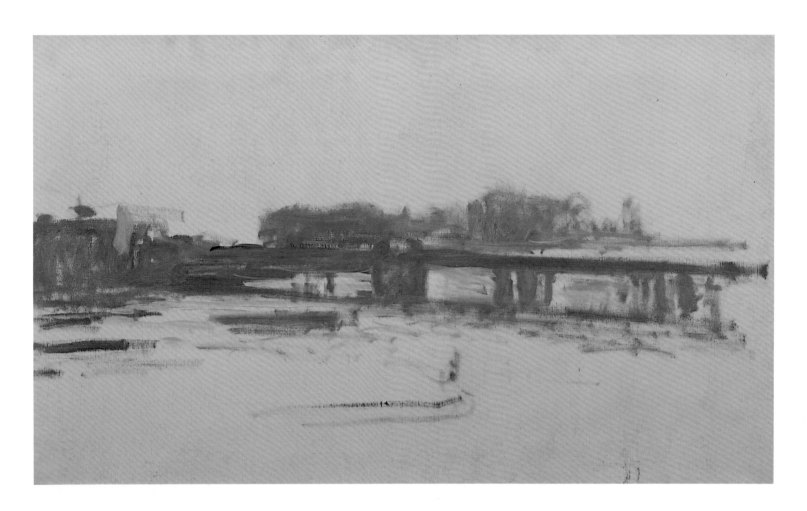

Fig. 46. *Charing Cross Bridge*, 23½ x 39⅜ inches (60 x 100 cm), Musée Marmottan, Paris.

Fig. 47. *Portrait of Monet*, ca. 1900, photograph, Galerie Durand-Ruel, Paris.

58

61. E. M Rashdall, "Claude Monet," *The Artist* (2 July 1888), quoted in Flint, *Impressionists in England*, p. 308. This account is corroborated by Lila Cabot Perry, "Reminiscences of Claude Monet from 1889 to 1909," *American Magazine of Art* 18 (1927): 120: "He held that the first real look at the *motif* was likely to be the truest and most unprejudiced one, and said that the first painting should cover as much of the canvas as possible, no matter how roughly, so as to determine at the outset the tonality of the whole." See also House, *Monet: Nature into Art*, pp. 65-66.

show much of it. This Marmottan study also gives an idea of how Monet began at least some of his paintings. He laid in the structure of the bridge, but he also suggested the brightness of sunlight reflecting off the water. His letters establish clearly that not all of his paintings ended up with their original effects; however, this study suggests that Monet worked from the start with color harmonies and light effects.

Monet's interest in establishing an effect over the entire canvas, without attention to the color of specific objects, during his first period of work was attested to by several people who had seen his paintings under way.

> The work is purposely kept extremely open, . . . as nothing is laid on . . . for the sake of "covering the canvas". . . . The one golden rule from which Claude Monet never departs is to work on the whole picture together, to work all over or not at all. Neglect of this leads to loss of all harmony. . . .[61]

While Monet's letters give an idea of his work in London, they are reticent about many matters. They report on how he spent his time and on his daily routine. They discuss his negotiations in arranging to work at St. Thomas's Hospital, and later at the club overlooking Leicester Square. They describe his social encounters. However, they say relatively little about the paintings themselves and don't mention particular works. Indirectly, however, they give insight into the process that led to the complex color effects and enriched surfaces of these views of London.

The letters express Monet's pleasure in seeing and his struggle in painting. They show his preoccupation with light and atmosphere. He seldom mentioned buildings, and alluded to boats and trains only by their absence. "What a dreary day this damned English Sunday is, nature feels the effects, everything is dead, no trains, no smoke, no boats, nothing to inspire me" (w. 1616).

Nearly every day he reported on the weather. He often would say it was beautiful, even superb, or terrible, or sad and monotone. Above all, he wrote about its variability. No two days were the same, which he found both difficult and rewarding. He wrote about his "habitual changes" (w. 1523). In 1901 he wrote to Alice: "I can't tell you about this fantastic day. What marvelous things, but only lasting five minutes, it's enough to drive you crazy. No, there's no land more extraordinary for a painter" (w. 1593).

The letters suggest that Monet saw himself as passively at the mercy of an unpredictable nature which often prevented him from finding the effects he sought. At times he personified the weather. "Alas the fog doesn't want to dissipate and I'm afraid of losing my morning. . . . But look who shows his face, the sun, is he going to be serious?" (w. 1519).

Monet's discussions of the sun—its presence or absence, and its effect—give perhaps the fullest sense of how he responded to changes in the weather, and

the consequences of the change of seasons for his work. The sun itself—the "pretty red ball of the sun" (w. 1597)—appears in Waterloo Bridge paintings (such as fig. 65) and one Charing Cross Bridge (fig. 15) as an orangy-red impasto mark. Monet wrote that he dreamed of doing the sun "setting in an enormous ball of fire behind the Parliament" (w. 1527), but because the towers provided precise markers for the sun's position it was especially difficult for Monet to find his effects again in this group. The sun would appear to move to the north between mid-winter and mid-summer: to the right in the Houses of Parliament paintings and to the left above Waterloo Bridge. In fact the paintings do not show a clear chronological succession of effects; the disappearance and movement of the sun was a frustration to Monet, who wanted the same effects to repeat themselves. In early March 1900 he wrote:

> The same weather as yesterday, and still no shadow of sun or break in the clouds, which annoys me very much; I have a lot of things I can't work on; it distresses me, because time marches on and the sun too, with the result that the day when it decides to appear, it will no longer be in the same place. It's especially troublesome for my canvases at the hospital. (w. 1525)

On the 24th of March he was even more discouraged.

> Around 4 o'clock the sun finally showed itself from time to time and I was thrilled for the motifs at the hospital, but there I was completely disappointed; a few days without seeing it, the sun, and it appears a kilometer from my motif; there is no longer any hope on that front, and I'm really distressed about it! It would have been so beautiful to do! . . . Nevertheless I'm going to continue to go to the hospital to try to save the canvases without sun, but they are only rough sketches [*ébauches*]; and I'm capable of having sun every evening. (w. 1537)

The sun appears as a ball of fire in only a few of these pictures (W. 1596, W. 1602, W. 1604). In others, it is a bright spot in the sky behind the clouds (fig. 53). Still others show simply an atmosphere colored by the sunset (figs. 52, 67) grading into more foggy effects (figs. 17, 49, 55).

In 1901 Monet wrote to Alice that he was afraid he would have to give up on all the motifs where the sun played a part because he hadn't seen it for two weeks and "God knows the change that I will find if it returns. Well, I'm cutting my losses on the gray and foggy motifs, and that's going better" (w. 1610).

Even without the sun, the change of seasons meant that he couldn't continue working: "At this moment a great transformation in the weather is happening, the sun, although rarely visible . . . is climbing, becoming stronger, and is changing the state of the atmosphere absolutely" (w. 1613). To make paintings from effects in flux implies finding distinctions. The descriptions in Monet's letters give some idea of the effects he attended to and of the way he began to classify his paintings. Once established, types could be repeated in variations

Fig. 48. Paul Nadar, *Alice Monet*, 1899.

59

which became sequences within the series.

For instance, Monet described morning light penetrating the fog: "Beginning at 10 o'clock the sun showed itself, a little veiled at moments, but with admirable effects of sparkles on the water" (w. 1604). The Santa Barbara *Waterloo Bridge* (fig. 26) shows such an effect. The Milwaukee *Waterloo Bridge, effet de soleil* (fig. 10) also shows sparkles, but over less of the water, with a tonality suggesting early morning. The Baltimore *Waterloo Bridge* [*Effet de soleil avec fumées*] (fig. 11) shows a similar effect of light, but with denser fog which blends the reflected gleams and with smoke. Several of the Charing Cross Bridge views such as the Baltimore *Charing Cross Bridge* [*Reflets sur la Tamise*] (fig. 31) show related afternoon effects. "The whole Thames was gold. God but it was beautiful, so much so that I went to work with a frenzy, following the sun and its shimmers on the water" (w. 1593). Related paintings, such as the Boston, Shelburne, and St. Louis views (figs. 14, 40, 41), show similar light effects with varied intensity and tonality, and with differing densities of atmosphere.

Some of the kinds of effects he described in his letters do not always appear in paintings made at the time. The yellow atmosphere in a view of Charing Cross Bridge in Cardiff, which is not a morning effect (fig. 33), resembles something Monet described in a letter of 1900: "This morning at daybreak there was an extraordinary mist entirely yellow; I made an impression of it, not bad I think" (w. 1519). Such preliminary impressions were often transformed when effects did not return, or when they did not fit in with other paintings in the series.

Although the atmosphere Monet was painting was often very polluted, he acknowledged this relatively infrequently; in some of his paintings—especially but not exclusively those showing gray days (such as fig. 37)—patches of brownish or greenish paint indicate the industrial origin and the dirtiness of the fog. At times Monet wrote about this color, which he chose not to pursue, although he never mentioned the smell or feel of it—the memory of which may have been partly incorporated in his "sensations."

> It's hard to have beautiful things to paint and to have suddenly in front of you a layer of darkness of an unnameable color. . . . Alas, the fog persists, from dark brown it has become olive green, but always as dark and impenetrable. (w. 1604)

Some of the variations in his works had to do with thickness of fog and with breaks in the fog, which he often alluded to in his letters. He used two words for fog: "*brouillard*"—most often—and "*brume*." Their use in titles in works in this exhibition suggests that the distinction may be partly that "*brouillard*" is denser; for instance, a work exhibited with the title *Le Parlement, effet de brouillard* (the St. Petersburg *Houses of Parliament, London*, fig. 49) contrasts with

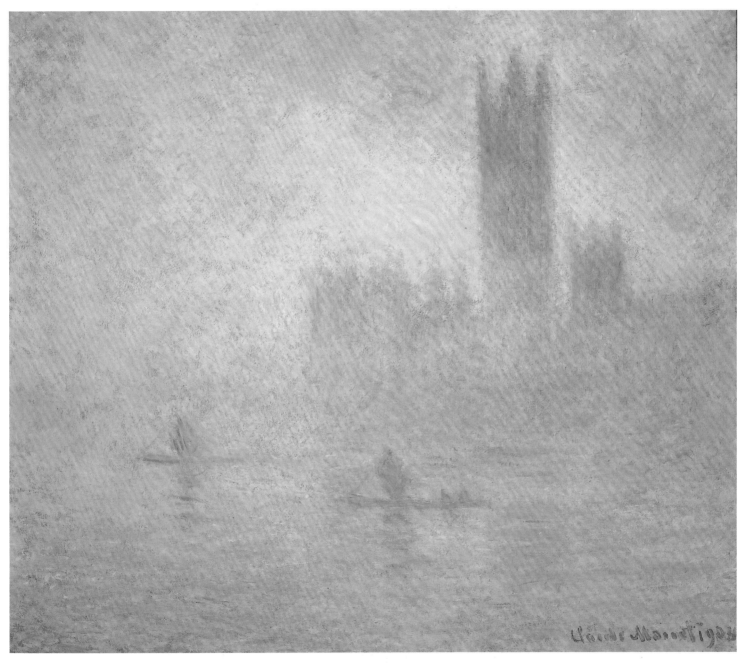

Fig. 49. *Houses of Parliament, London* [*Effet de brouillard*], 32½ x 36½ inches (82.5 x 92.7 cm), Museum of Fine Arts, St. Petersburg, Florida, gift of Mr. and Mrs. Charles Henderson and Friends of Art. Cat. no. 22.

the effect in *Matin brumeux* (the Philadelphia *Waterloo Bridge, Morning Fog*, fig. 50). However, this is not a standard distinction in French. "*Brume*" according to Littré is used above all in speaking of sea fogs,[62] and Monet may have been incorporating some memory of the quality of the fog.

Similar effects in paintings showing different motifs served to connect the series, but each motif also came to have distinctive features. The Charing Cross Bridge paintings, with their similar effects and relatively unified palette, seem to have resolved themselves most easily; Monet dated five of them 1899 and sold them, along with one Waterloo Bridge, before the 1904 exhibition (W. 1521-24, W. 1531, W. 1555, figs. 26, 40). He kept the other twenty-nine. Waterloo Bridge, on the other hand, was shown in forty-one surviving paintings, the largest and most varied group of works in the series. Not only did Monet develop a large group of gray day effects (figs. 8, 37, 38), he also departed from his practice of looking toward the sun, as he usually did with Charing Cross Bridge and the Houses of Parliament, and painted afternoon effects in which the side of the bridge toward him was illuminated (figs. 12, 56, 62). When Monet arrived in London for his last period of work, in 1901, he began by working only on the paintings of Waterloo Bridge (w. 1595), perhaps because these presented the greatest difficulties.

The series of the Houses of Parliament is the most unified and perhaps the one with which Monet was most satisfied. He exhibited eleven of the nineteen identified paintings, and asked a higher price for them than for the other paintings in the series (20,000 francs instead of 15,000).[63] No sketchy versions have survived, and Monet may have begun with a clearer idea of what he was doing than with the earlier groups. Unlike views of the bridges, the Parliament paintings are all the same size, and all show late day and sunset effects; working in St. Thomas's Hospital, Monet looked nearly due west. The massive neo-Gothic building is flattened to a pattern of towers and pinnacles, sometimes doubled in reflection (figs. 17, 52).[64] Although the amount of the building that shows varies, it dominates the picture.

Although his decision to paint only more or less foggy scenes automatically gave a unity to the series, his work on the paintings narrowed the kinds of effects he treated. The main variations in the series are chromatic; the relatively minor changes in position and cropping do not affect the experience of reading the succession of paintings as much as the colors. He told an interviewer in 1901 about his perception of colors in the fog:

> The fog in London assumes all sorts of colors; there are black, brown, yellow, green, purple fogs, and the interest in painting is to get the objects as seen through all these fogs. My practiced eye has found that objects change in appearance in a London fog more and quicker than in any other atmosphere, and the difficulty is to get every change down on canvas.[65]

62. E. Littré, *Dictionnaire de la langue française* (Paris: Hachette, 1873-86), s.v. *brouillard*, *brume*.
63. Wildenstein, *Monet*, 4, pièce justificative 170, J. Durand-Ruel to Cassirer, 7 September 1904.
64. Joel Isaacson, *Observation and Reflection: Claude Monet* (Oxford: Phaidon, 1978), p. 226, points out that the arrangement of the towers (the tallest one of which has been made taller and thinner) suggests that Monet was painting the building from an angle, but, as in the case of the Poplars and the paintings of Rouen Cathedral, he denied the angle.

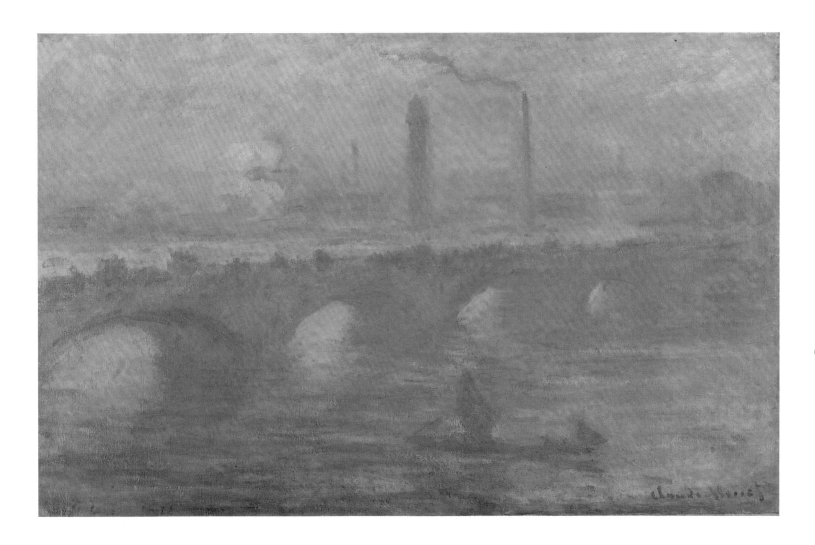

Fig. 50. *Waterloo Bridge, Morning Fog [Matin brumeux]*, 25⅞ x 39⁷⁄₁₆ inches
(65.7 x 100.2 cm), Philadelphia Museum of Art, bequest of Anne Thomson as a
memorial to her father, Frank Thomson, and her mother, Mary Elizabeth Clarke
Thomson. Cat. no. 7.

All of these colors (except black) and more, appear in Monet's London paintings, but always intermingled with others. The distinction between effects of gray weather and those in which the sun was present provided a basic division in the paintings. Those with sun tended toward light blues, blue-greens, yellows, pinks, and violets, while the sunless effects, especially in the Waterloo Bridge paintings, have darker blues, green, grays, browns, and neutral colors made by mixing near-complementaries together (figs. 8, 37, 38). The sunset effects of the Houses of Parliament introduced a range of orange and reddish hues (figs. 52, 53). Despite their differences in effect, the paintings are linked in color. Nearly all the paintings have blues, especially in the distance where the colors of buildings are obscured by the atmosphere. Those which are less finished suggest that Monet used blues to establish the structure in at least some of his compositions.

In late January 1900, he made sketches with pastels while he waited for his paintings to clear customs. The medium was unusual for him. He wrote that he really would like to be seriously at work, but he wasn't wasting his time, because he was looking a lot, and observing what he should do. The studies in pastel were like exercises (w. 1589, w. 1590), and appear to be color studies, contrasting small strokes and touches of contrasting hues to the overall tonality of the background and the related colored strokes defining the edges of forms (fig. 51).[66] The views of Leicester Square (fig. 25) also are notations of color rather than forms.

Monet habitually used a very small number of colors. In a letter of 1905 to Georges Durand-Ruel, he replied to an inquiry about his palette.

> As to the colors I use, is it as interesting as all that? I don't think so, considering that one could paint more luminously and better with a totally different palette. The main point is to know how to use colors, the choice of which is only a matter of habit. To make a long story short, I use silver white, cadmium yellow, vermilion, rose madder deep [*garance foncé*], cobalt blue, emerald green and that's all. (w. 1780)

Because of his long experience of using these colors, he knew what combinations he could mix in order to convey the effects he wanted. Of course the relation between his color perception and what he painted was affected by his habitual use of color; he could translate what he saw into paint because he was familiar with the pigments' properties.

The subtlety of Monet's effects was attested to by Gustave Geffroy, a critic and Monet's biographer, who visited the artist along with Georges Clemenceau in February 1900. He found Monet installed on a balcony.

> He remained faithful to his method of work . . . which is strictly accomplished from nature. . . . He accumulated his touches . . . with a prodigious certainty,

64

65. E. Bullet, "Macmonnies, the sculptor, working hard as a painter," *The Eagle* (Brooklyn) 8 September 1901, quoted in House, "Impressionist Vision of London," p. 88.
66. The works on paper will appear in a fifth volume of the Wildenstein catalogue raisonné.

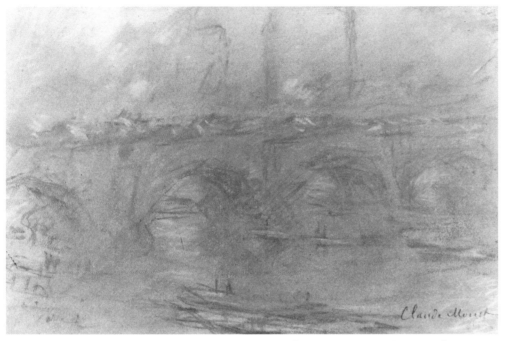

Fig. 51. *Waterloo Bridge*, pastel on paper, 12¼ x 18⅞ inches (31 x 48 cm), private collection.

knowing exactly to which phenomena of light they corresponded. From time to time, he stopped. "The sun isn't there any longer," he would say. . . . All of a sudden Claude Monet would seize his palette and his brushes. "The sun has come back, " he said. He was at that moment the only one to know it.[67]

Because Geffroy could not see the distinction Monet registered, he concluded that the artist's perceptions were so finely tuned that he could see what others missed. He wrote:

We looked in vain, we still only saw an expanse of woolly gray, some confused forms, the bridges as if suspended in the void, smoke that quickly disappeared, and some swelling waves of the Thames, visible close to the bank. We applied ourselves to see better, to penetrate this mystery, and, indeed, we ended up by distinguishing we didn't know what mysterious and distant gleam, which seemed to be trying to penetrate this immobile world. Little by little, things were illuminated with a gleam and it was delicious to see, feebly illuminated by an invisible sun, like an ancient star, this grandiose landscape that then delivered its secrets.[68]

67. Gustave Geffroy, *Claude Monet: sa vie, son temps, son oeuvre*, 2 vols. (Paris: G. Crès & Cie., 1922), 2: 129-30.
68. Ibid., pp. 130-31.

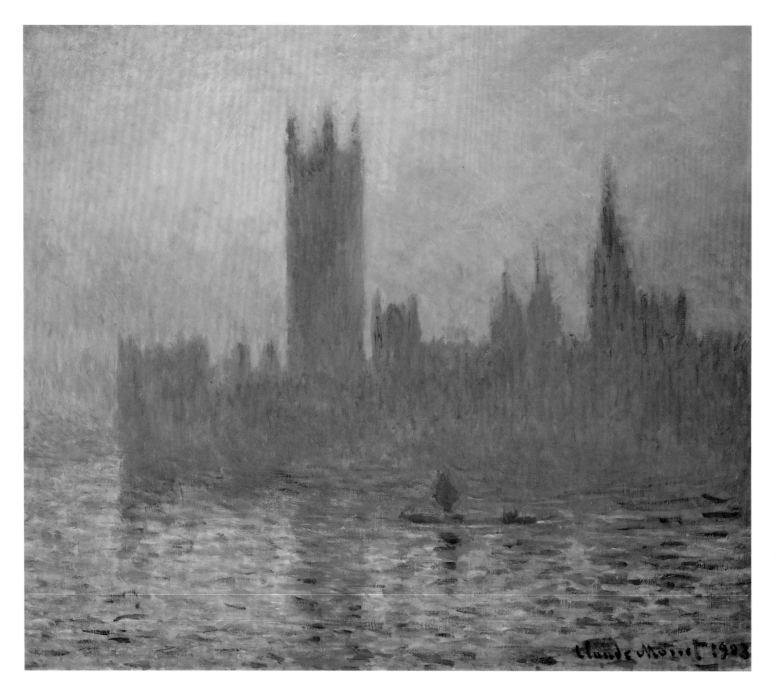

Fig. 52. *The Houses of Parliament, Sunset*, 32 x 36⅝ inches (81.3 x 92.5 cm), National Gallery of Art, Washington, Chester Dale Collection.

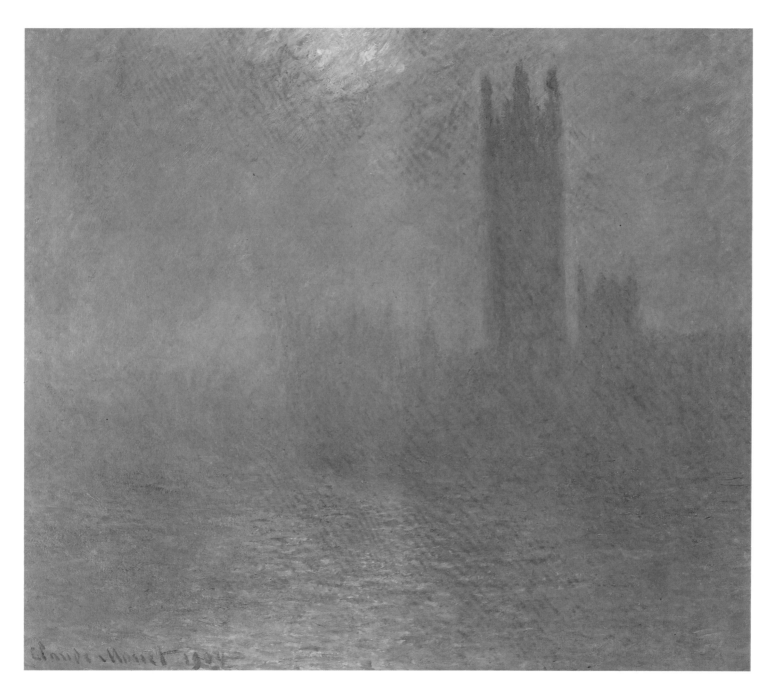

Fig. 53. *Londres, Le Parlement, trouee de soleil dans le brouillard,* 31⁷/₈ x 35³/₄ inches
(81 x 92 cm), Musée d'Orsay, Paris.

Geffroy's account leaves open the possibility that the chromatic effects in Monet's paintings of this "woolly gray" were either the result of an extraordinarily sensitive eye—as Geffroy, committed to the notion of Monet's naturalism, implied—or were the notations of a subjective response. In either case, such subtle changes were certainly not verifiable and were extremely difficult to find again. Geffroy's assertion of Monet's "prodigious certainty" is belied by the artist's letters.

The letters give a sense of Monet's constant struggle with changes in the weather and his frustration with effects that did not return. In 1900 he wrote to Alice in mid-March (14th):

> I'm not at all discouraged and am still full of ardor, but I'm anxious and I'm fretting because I can't work often enough on the same canvases; there are some on which I've only worked once; others twice; it's terrible, but it's also so variable . . . it's sad, because it's so beautiful. . . . Well, I've never been in such good form, but I'm beginning to get tired, because it's a tough job I'm doing, and as the days lengthen, I'm working eleven hours a day. (w. 1529)

Four days later he wrote to Alice:

> Every morning it's the same, I get carried away until the weather gets in my way. Today a day of terrible struggle, and it will be the same until I leave. Only I need more canvases; because it's the only means to achieve anything, in starting them in all weathers, all harmonies, it's the only means and, at the beginning, you think you will find the effects again and finish them: but then, these wretched transformations which don't do any good . . . I have something like 65 canvases covered with colors . . . What a bill I'm going to have at Lechertier! For my return, I said that I would come back at the beginning of April, and I will; but what do you want me to do when I don't have the effects I want, do nothing or transform, which is the worst thing. It's better to continue the struggle and to begin [more], and I'm sorry I didn't do it squarely from the beginning. (w. 1532)

He wrote of switching paintings; he mentioned to Alice that he had already worked on four canvases by nine o'clock or that he had been working on more than fifteen canvases in turn (w. 1593, w. 1533). At times he wrote about attempts to achieve some control—by limiting himself to working on ten Waterloo Bridge paintings, for instance—but these were only moderately successful.

In a later interview with the duc de Trévise Monet gave a vivid picture of the difficulties involved in trying to paint elusive light effects.

> Where it became terrible was on the Thames; what a succession of aspects! At the Savoy Hotel or St. Thomas' Hospital, from which I looked at my points of view, I had up to a hundred canvases under way—of the same subject. By searching among the sketches [ébauches] feverishly, I chose one of them that didn't differ too much from what I saw; despite everything, I altered it completely. When my work was finished, I would notice, in moving my canvases,

that I had overlooked precisely the one that would have suited me best and which I had at hand. How stupid![69]

His project went through predictable phases. Monet arrived enthusiastic, and with some kind of vision of what he wanted to accomplish. As time went by, the work seemed more complicated and less capable of completion. He wrote to Alice in March 1900:

> When you have time before you, you believe you're certain to succeed, but when you only have a few days left, it becomes frightening; there's no point in wanting to stay longer, because it wouldn't change anything, considering that there would be other canvases to do. (w. 1531)

The mechanics of working on many paintings created difficulties, but his uncertainty about how to carry them to completion was not merely the result of technical problems. At the end of each of his stays, he realized that he would not be able to complete the works that year.

From past experience he knew that his effects would not return, but he continued to foster the hope that he could finish paintings on the spot. However, he acknowledged that he began paintings without knowing whether he would finish them; he wrote to Durand-Ruel on 7 March 1900:

> I don't need to tell you that I work without stopping, but I have a great deal of trouble because of the continual changes in weather, which oblige me to do many more paintings than I will be able to finish, and this involves me in enormous expenses. (w. 1524)

In Monet's early days, a sketchlike work that was complete in its own terms satisfied him (fig. 36). But in his later paintings, his rapid notations provided the basis for further work. He most often wrote of his works as canvases (*toiles*), but sometimes used words suggesting that he considered them only beginnings. He referred to them as *pochades*, *études*, *ébauches*, *essais*, and less frequently *croquis*. Monet does not always seem to have given the terms their narrowest meaning, or made distinctions he would have known from his academic training. A "*croquis*" was a very rough sketch, the first outline of an idea, which could be on paper or canvas. A "*pochade*" was a rapid, loose sketch, similar to a first draft in writing. An "*étude*" was a study which had traditionally been preparatory, but works done directly from nature were exhibited in the later nineteenth century. An "*ébauche*" was the first stage of a work on a canvas intended for completion. A "*tableau*" was the final product. "*Essai*" is not strictly a painting word, but implies an experiment.[70]

Monet's letters toward the end of his London stays sound driven and frustrated. He said he was wasting color (w. 1598). He worried that he was ruining things by reworking them. In March 1900 he said, "I had to take more than 15 canvases by turns, putting them down to take them up again, and it was never

69. Duc de Trévise, "Le Pèlerinage de Giverny," *Revue de l'art ancien et moderne* 51 (1927): 126. Reprinted in Stuckey, *Monet: A Retrospective.* See also Charteris, *John Sargent*, p. 126: "Sargent used to say that when he visited Monet at the Savoy Hotel, he found him surrounded by some ninety canvases . . . When the effect was repeated and an opportunity occurred for finishing the picture, the effect had generally passed away before the particular canvas could be found."

70. Littré, *Dictionnaire de la langue française*, s.v. *croquis, ébauche, esquisse, essai*. Steven Z. Levine, *Monet and his Critics* (New York and London: Garland Publishing, 1976), passim, discusses these terms. House, *Monet: Nature into Art*, pp. 157-62 and passim, discusses the practical applications.

the thing I was looking for—some pitiful brushstrokes" (w. 1533). And a few days later he wrote again:

> Well, I'm doing my best. That doesn't prevent me, despite progressing each day in the comprehension of this very peculiar climate, from putting big slashing brush strokes on the canvases that have given me a lot of trouble, nearly finished, but that were not London enough, and that's what I seek to do with these big brushstrokes. (w. 1539)

Sometimes he wrote about works that resolved themselves, but always indicated that others remained unfinished.

> A better day, although with a lot of trouble, and I don't advance, I'm still at the same paintings which will come out all of sudden, but how many canvases will be left in the lurch if this continues. (w. 1601)

In 1901 he wrote:

> To continue a canvas is almost impossible. I transform canvases, and often those which were passable become worse. No one will ever know the pains I've taken to achieve so little. (w. 1611)

His comments about what he was doing in taking up the paintings again suggest that he was making fairly large and distinct brushstrokes—perhaps impasto touches, later developed in the studio, that indicate reflections (figs. 15, 65) or the patches of contrasting color that give some feeling of the substance and color of the fog (fig. 28) or the brushstrokes that seem to float out and suggest palpable fog in the Marmottan *Le Parlement, soleil couchant* (fig. 54).

In beginning more paintings than he would finish he deferred the decision about which paintings would be carried further. However, in doing so he also devalued the individual work in favor of the entire series. His letters show that the process of working on the paintings involved coming to an understanding of what he was doing. In 1901 he wrote to Alice as he had to Durand-Ruel the year before: "I begin to understand; I will have put in the time, it's true, but I hope to get something out of some canvases" (w. 1610).

One way he developed his ideas was to spend time looking at his paintings. He mentioned in several letters that he did this before going to bed and he even brought canvases back from the hospital to see them better (w. 1528, w. 1599).[71] This was a way for him to be able to imagine what he wanted to do. His work and his way of thinking about it evolved increasingly toward pre-visualization. Later in his life he told an interviewer:

> One isn't an artist if one doesn't have his painting in his head before executing it, and if one isn't sure of his craft and his composition. . . . Techniques vary. . . . Art remains the same: it is a transposition of nature which is both voluntary and sympathetic.[72]

71. House, *Monet: Nature into Art*, p. 243 n. 3, also cites some witness accounts. See also Chapter 10.
72. Interview with Marcel Pays, *Excelsior*, 26 January 1921, quoted in Geffroy, *Monet*, 2: 166.

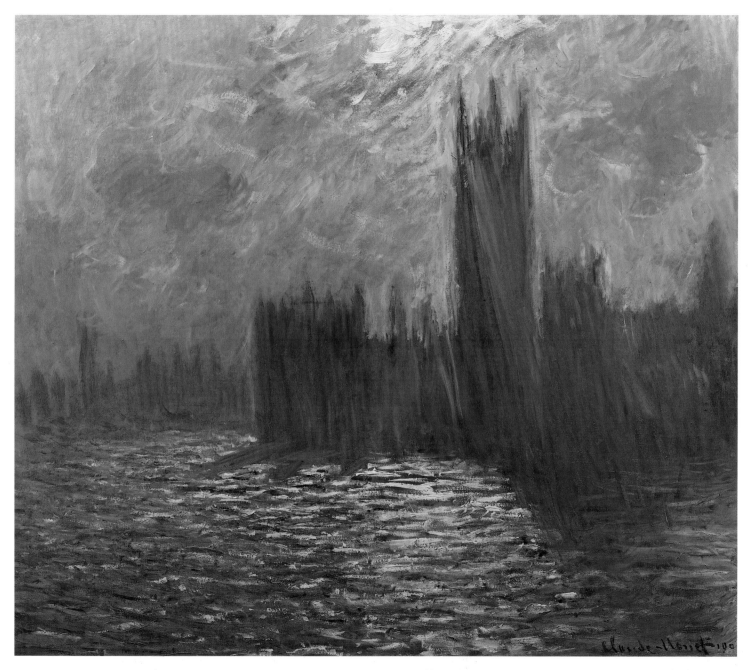

Fig. 54. *Le Parlement, soleil couchant*, 31⅞ x 35¾ inches (81 x 92 cm),
Musée Marmottan, Paris.

His work on the spot was shaped by conflicting wishes: to preserve the quality of the first look at the motif, which he had told Perry was "the truest and most unprejudiced one,"[73] and to know what the work should look like in advance.

His writing suggests something of the emotional, even the compulsive nature of the enterprise. He could be in the heat of work (w. 1535). It could be enough to drive him crazy (w. 1593). And he wrote of "this love that I don't cease to have for this damned painting" (w. 1614).

> I don't need to tell you that I work like a madman and that's the right term, as you know, and if it weren't for my evenings out and dinners in town, which are rather frequent, I would become stupefied with it, not being able to stop myself from looking at my canvases and thinking about them without stopping. (w. 1528)

Especially in 1900 he used the word "*lutte*," which means struggle or fight (for instance, w. 1532, w. 1539).

> As I told you this morning, I wanted to get back to work and, despite superb weather, I have only messed up some canvases. . . . In short, I think I'm going to attend to my departure; I no longer have the heart for the struggle; it's over; and I, who thought I would return content and victorious! Macache! it's less than nothing, and I've managed to destroy what I had been able to do with so much difficulty. (w. 1545)

In a letter of February 1901 to Alice he described his drive to do things again as a sickness: "And all this malady to always redo, retry differently without succeeding at what I want" (w. 1606a). Levine points out that Monet's letters are filled with "re"-words—that he constantly rewrites about redoing, reworking, refinding. "Rather than learn from the painful lessons of the past, Monet regressively repeats them as tragic farce."[74]

Complaints about effects that failed to return were already appearing in his letters of the early 1880s, yet Monet continued to seek more subtle and evanescent effects, which he was even less likely to find again. His working methods can be seen as the manifestation of a neurotic or even more disturbed psyche; they can also be seen as resulting from a clash between Impressionist ideals of painting one's sensation and the realities of creating a work of art. Whatever the explanation, Monet could not complete his paintings on the spot.

73. Perry, "Reminiscences of Claude Monet," p. 120.
74. Levine, "Monet's Series: Repetition, Obsession," pp. 72-73.

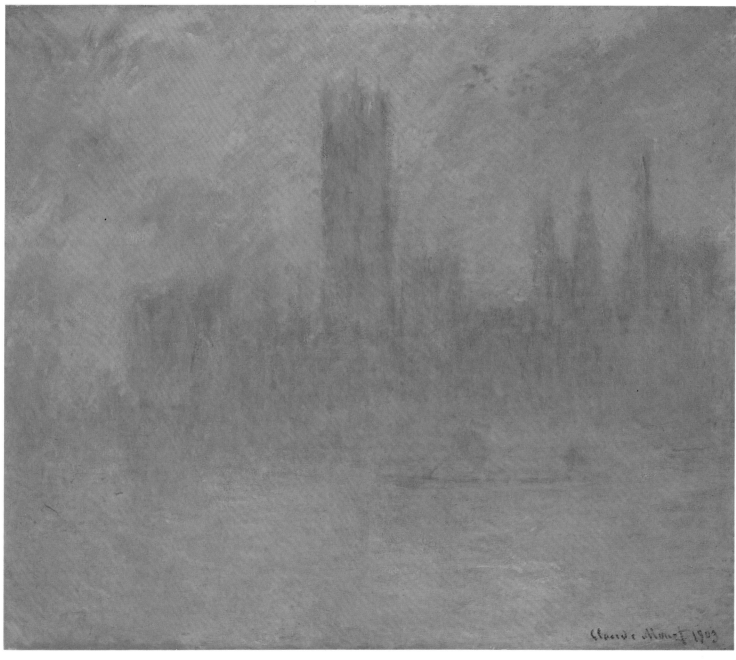

Fig. 55. *Houses of Parliament in the Fog* [*Effet de brouillard*], 32 x 36⅜ inches (81.3 x 92.4 cm), High Museum of Art, Great Painting Fund purchase in honor of Sarah Belle Broadnax Hansell. Cat. no. 21.

At Work in the Studio

Monet did not paint in London after 1901, but he did not exhibit the series until 1904 because he did not feel it was ready. In the intervening time he worked on the canvases in his studio, and in fact continued to work on some of the paintings even after the exhibition.

Finishing the paintings in the studio was a compromise between Monet's dedication to painting directly from nature and his wish to achieve what he wanted, which extended beyond the individual canvas to the entire series. It also meant that he had to overcome his tendency to defer completion and to keep returning to the works. Direct notation provided only a beginning. Work on many canvases helped him to clarify what he had in his mind and to express it. He had long acknowledged that he was interested in conveying not simply appearances, but his sensations and emotions. In resolving his paintings, Monet depended on his memory and technical mastery, but he had to create his own criteria for finish. Nineteenth-century academic standards had involved illusionism and minimizing evidence of the artist's hand; those of the avant-garde had challenged these notions and insisted on what became the twentieth-century standard: the creation of a satisfactory effect. For Monet a painting was finished when it was complete in its own terms, and when it corresponded not necessarily to a specific natural effect, but to his response, his imagination, or his recognition that the work had found its place in the total effect of the series.

Monet's decision not to return to London was probably based on his recognition that he couldn't complete the pictures there. He told the duc de Trévise, who was asking him about the Thames paintings, that he could find effects again. His interviewer said:

> You are so sensitive to the least changes in lighting! Furthermore, does nature really offer you the absolute equivalent of an aspect that you had already sketched, and can you have up to five or ten sittings on the same canvas, seeing exactly the same view?

Monet replied: "Certainly, up to twenty or thirty: it takes a longer or shorter time, that's all."[75]

However, his letters reveal that this was not the case. He couldn't count on seeing the same thing again, not only because of changes, but also, perhaps, because what he saw could never be the exact equivalent of something he remembered. He had talked of this problem in relation to his Haystacks. "One has to know how to seize the moment at the right time because this moment will never return, and one always asks oneself if the impression one received was the right one."[76]

Work based on memory, and on looking at the paintings together, had become an integral part of the series. Beginning with the Haystacks, he had lined the canvases up in his studio and painted them as a group.[77] In his later

75. Duc de Trévise, "Le Pèlerinage," p. 126.
76. W. G. C. Byvanck, *Un Hollandais à Paris en 1891* (Paris: Perrin, 1892), p. 176, partially translated in Stuckey, *Monet: A Retrospective*.
77. Maurice Guillemot, "Claude Monet," *Revue illustré*, 13 (15 March 1898), n.p., visited the artist while his Mornings on the Seine were lined up to be worked on simultaneously and reported that the procedure had begun with the Haystacks. Translated in Stuckey, *Monet: A Retrospective*.

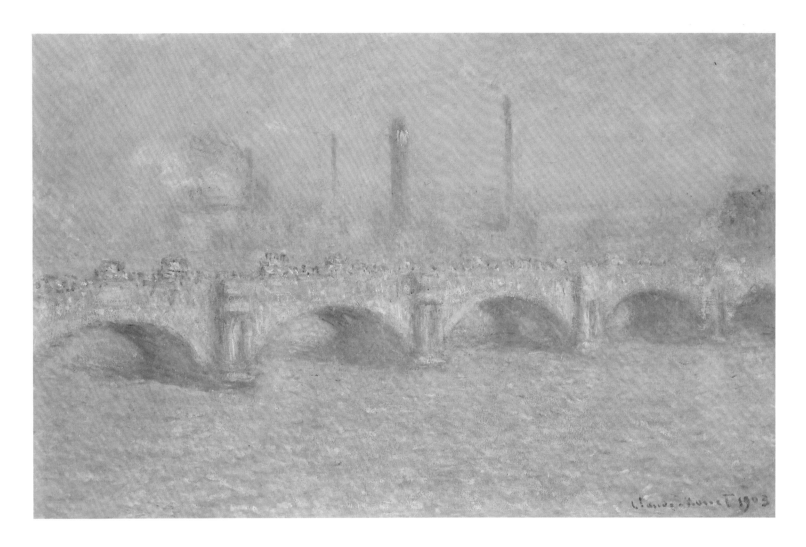

Fig. 56. *Waterloo Bridge, Clouded Sun,* 25½ x 39¼ inches (64.8 x 99.7 cm), Memorial
Art Gallery of the University of Rochester, gift of the estate of Emily and James
Sibley Watson. Cat. no. 18.

Fig. 57. *Monet and the Duc de Trevise in Monet's Studio*, 1920, photograph, H. Roger-Viollet, Paris.

78. Herbert, "Method and Meaning in Monet," and House, *Nature into Art*, discuss Monet's paint surfaces. Herbert refers to Monet's "texture of spontaneity" (p. 97). Richard Shiff, *Cézanne and the End of Impressionism* (Chicago: University of Chicago Press, 1984), in Chapter 8 discusses what he calls "the technique of originality" with reference to Monet.

79. E. Bullet, "Macmonnies, the sculptor, working hard as a painter,"*Eagle* (Brooklyn), 8 September 1901, quoted in House, *Nature into Art*, p. 165.

80. Georges Clemenceau, *Claude Monet: The Water Lilies*, trans. by George Boas (Garden City, N.Y.: Doubleday, Doran & Company, 1930), pp. 32-33.

81. Perry, "Reminiscences of Claude Monet," p. 121.

paintings the kinds of effects he chose were adapted to the multiple periods of work and to the layered surface that they yielded.

In his paintings of the 1870s, the classic Impressionist works, touches of color had had distinct shapes corresponding to specific visual phenomena (fig. 36). While conventions for showing the reflections on rippled water are similar in Monet's first London paintings and some of the later Thames paintings (figs. 5, 52), the overall treatment of surface in the later works differs from the varied separate touches of early works. Many of the Thames paintings have vaguely defined areas of color effects created by layers of one color over another (fig. 58). Their present surfaces, which resulted from multiple periods of work, are thin in places and in others dense and crusted from repainting.

Because Monet was interested in atmospheric effects and not in specific qualities of objects, he could alter the tonality of works, change emphasis, or introduce or change smoke, clouds, and reflections without losing the immediacy of the impression. Despite the long periods of work, gestural brushstrokes and individual spots and dabs of paint communicate an immediacy and originality which Monet cultivated. His technique signified spontaneity, but a careful look reveals his long effort and uncertainties.[78] He concealed the extent of his work on the paintings, both in his actual execution and in the way that he discussed it with visitors, like the duc de Trévise, to whom he stressed his direct response to nature. He was more candid in some cases; he told an interviewer around 1900:

> Most people think I paint fast. I paint very slowly. I am never contented with my work. I let a picture go because I would work on it forever if I did not. When I was younger I used to expedite matters much more than I do now. I am getting harder and harder to please.[79]

Seen up close, the paint surface can appear chaotic. In views of Waterloo Bridge (figs. 56, 62) the multiple periods of work are apparent in the way in which the brushstrokes of the blue underlayer move in a different direction from those of the violet, pinkish-violet, yellow, or brown touches on top. Colors show through others dragged over them. It is only from a distance that the buttresses take on volume, the blue-greens under the arches give the shadows vibrancy and the arches depth, and the buildings in the distance assume some form. The complex overlays of color helped Monet to create the illusion of shifting unstable effects.

Clemenceau reported that Monet was able to work on such pictures without stepping back,[80] and Perry reported that Monet had told her "every young painter should train himself to sit near his canvas and learn how it would look at a distance."[81] Monet was able to visualize effects in terms of painting, but he was also creating a paint surface.

Fig. 58. *Waterloo Bridge, Clouded Sun* (detail of Fig. 56).

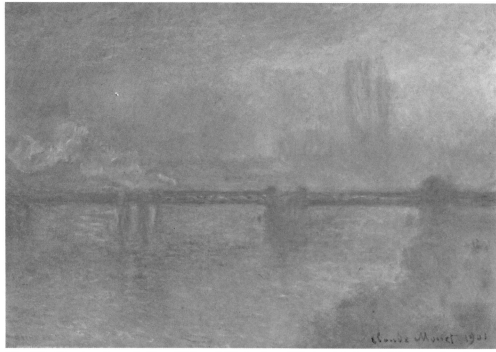

Fig. 59. *Charing Cross Bridge*, 25¾ x 36⅜ inches (65.4 x 92.4 cm), The Art Institute of Chicago, Mr. and Mrs. Martin A. Ryerson Collection.

The paintings Monet unpacked at Giverny probably included some works that were quite fully developed, like those he had already sold, and others that were just beginnings. In 1901 Monet invited Geffroy to see the "quantity of studies, sketches, experiments [*études, pochades, essais*] of all sorts" that he had brought back (w. 1632). The decision on what to do with them was a subjective one. At a later point, when he was worried that he had ruined his paintings by reworking, Monet told Geffroy that "these experiments, these sketches [*ébauches*] could have been shown" (w. 1692).

Finishing such paintings of atmosphere was a matter not of adding detail, but rather of resolving the works and giving them a distinctive character, of transforming the sketches into *tableaux*. Although Monet claimed that he had worked on all the paintings, some of them were left in a sketchier state than others. The Marmottan *Charing Cross Bridge, fumée dans le bruillard, impression* (fig. 60), with its two plumes of smoke from trains, is more loosely painted and undefined than two similar paintings of trains crossing (W. 1533 and W. 1534, both in private collections). Its title recalls Monet's *Impression, Sunrise*, and as

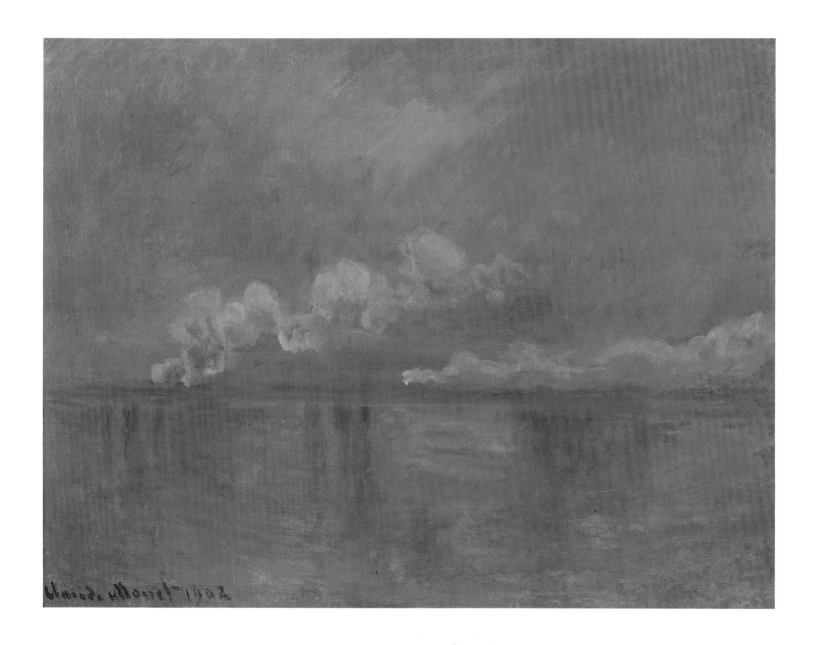

Fig. 60. *Charing Cross Bridge, fumee dans le brouillard, impression*, 28¾ x 36¼ inches
(73 x 92 cm), Musée Marmottan, Paris.

House points out, like other works entitled "impression," it is both summary in handling and shows an especially misty effect.[82]

The Indianapolis *Charing Cross Bridge* (fig. 61), which was not exhibited until after Monet's death, gives an idea of what some of the works must have looked like in the studio. Although it is sketchy, it was created by multiple returns and revisions. The only clues we have about how he was reworking his paintings in London are his complaints about his "big slashing brushstrokes," which suggest that some of its swirls and marks may have been the kind of notations Monet made on the spot. There is no way of ascertaining when work was done, but these large brushstrokes reveal that his revisions were not always refinements, but could involve major changes.

In the studio Monet tried to create from the paintings that he had brought back a result that somehow corresponded to what he remembered or imagined. It was a difficult task because of the ambiguities involved: his uncertainty about what he was doing, his difficulty in remembering the effects he wanted, and his desire to have the paintings work together. He wrote to Durand-Ruel in 1903:

> No, I'm not in London unless in thought, working steadily on my canvases, which give me a lot of trouble. . . . I cannot send you a single canvas of London, because, for the work I am doing, it is indispensable to have all of them before my eyes, and to tell the truth not a single one is definitively finished. I work them out all together or at least a certain number, and I don't yet know how many of them I will be able to show, because what I do there is extremely delicate. One day I am satisfied, and the next everything looks bad to me, but anyway there are always several good ones. (w. 1690)

The group, rather than the individual painting, had become the focus. Some of the most dematerialized paintings in the Thames series (such as figs. 15, 60, 63, 65) take on greater meaning in the context of the entire series. As Monet earlier had talked about working on the whole picture at one time, he now tried to maintain the harmony of the whole group of pictures. The process of looking at the works together was an extension of his practice of mulling over the canvases in his hotel room. When he could look only at the paintings, rather than out at the Thames, he had to make decisions based on what he could see in the works themselves.

Work in the studio served to clarify the effects and to give each painting its place in a succession. With similar views the relation in time was specified (figs. 10, 11, 31, 40, 41) both in tonality and in the indications of the movement of light, especially in reflections on the water. Late times of day were differentiated from early (fig. 63), although some remained ambiguous (fig. 66).[83] Distinctions in the relative clarity or obscurity of the background and bridges implied decisions on how far to carry the development of effects—how much

82. House, *Nature into Art*, p. 162.
83. Wildenstein, *Monet*, 4: W. 1564, proposes that the National Gallery's painting, because of its light eastern sky, shows a morning rather than an evening effect.

Fig. 61. *Charing Cross Bridge*, 26 x 36½ inches (66 x 92.7 cm), Indianapolis Museum of Art, gift of Various Contributions. Cat. no. 3.

detail to introduce and whether the surface would be handled broadly or more tightly (figs. 56, 63). Gray weather views frequently showed more detail, but the degree to which it was developed varied (figs. 8, 37, 38).

In some cases Monet gradated the effects as he created a more complex surface. The Cardiff *Charing Cross Bridge* (fig. 33) has a more broadly brushed surface with fewer impasto touches than related views (figs. 14, 31, 40, 41), which evoke more sparkling reflections. The impasto touches which convey the most vivid sense of light were added or enriched in the studio. In the Shelburne painting (fig. 40), for instance, the touches of light orange tones, put on with a rather dry brush, as well as yellows and creams, in dabs and flecks varied in shape and hue, are the top layer.

Some paintings which look extremely sketchy show signs of reworking. The *Waterloo Bridge, London, at Sunset* [*Effet rose*] (fig. 63) has been transformed by pink overlaying a blue tonality. The Rochester and Carnegie views of Waterloo Bridge (figs. 56, 62) both also show effects of afternoon light. They might have resembled the National Gallery painting in their early stages, but were developed more fully. Their similarities and differences indicate some of the ways in which Monet worked on the paintings which had very similar effects. The Rochester painting gives the impression of a slightly denser fog. Both have an underlying light blue hue, which characterizes much of the series, and in both yellows, pinks, and violets suggest the afternoon sun shining through the fog and emphasizing the relief and decoration of the buttresses. Both show the traffic on the bridge as yellow and orange spots, which suggest, in their rhythmic and rapid directional application, something of the movement of the carriages and omnibuses, and also relate in color to some of the sunset effects in the Houses of Parliament. This kind of effect was one that Monet could have worked up on a whole group of paintings, moving from one to another, putting on dabs of color and sharpening the illusion, or differentiating paintings that were too similar. The differences between these two paintings are not in degree of precision, nor in the kind of weather effect presented, but in nuance. The effects are created by subtle differences both in color and in execution. The Carnegie painting has a somewhat choppier touch on the bridge, and longer, more widely spaced strokes on the water, whereas the Rochester painting has vertical touches on the bridge and a more consistent, blended brushstroke, which gives the whole a more veiled appearance.

Besides working on sequences of paintings, Monet had to find ways to unify the separate groups within the series. Colors from other groups enrich basic tonalities. The blue-yellow Charing Cross Bridge paintings have many touches of greens, red browns, oranges, and other hues that connect them with some of the views of Waterloo Bridge. Touches of the violets and sunset hues of the Houses of Parliament appear in paintings of the other groups.

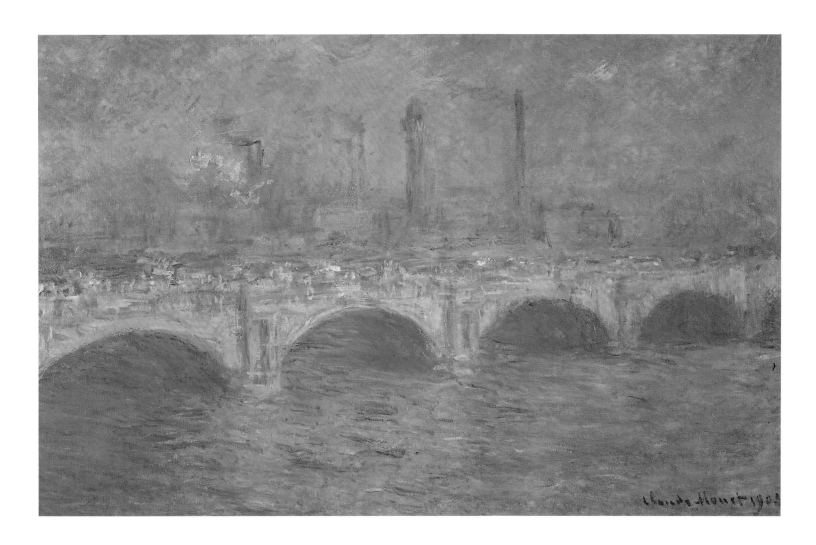

Fig. 62. *Waterloo Bridge, London* [*Effet de soleil*], 25⅜ x 39½ inches (64.5 x 100.3 cm),
The Carnegie Museum of Art, Pittsburgh, acquired through the generosity of the
Sarah Mellon Scaife family, 1967. Cat. no. 17.

Plumes of smoke in the paintings of the bridges serve to differentiate works with similar effects (figs. 37, 38); they also link disparate paintings through color as well as form. The Indianapolis painting (fig. 61), with its swirls of color, suggests the way in which Monet may have thought about incorporating them.

Boats were another unifying element as well as one which suggested the silent movement of traffic on the river. Monet especially liked the shape of the sails on barges (figs. 20, 33, 52). In a number of cases the shape and placement of the boats in two or three pictures are very similar and suggest that Monet worked them out at the same time.[84] The varied positions of the boats also created a kind of rhythmic variety in the series (figs. 43, 49).

Seagulls appear in two of the views of the Houses of Parliament (fig. 67 and W. 1613). They introduce another kind of movement into the shrouded atmosphere. The nearly identical placement of the birds indicates that these were alternative views; they were among the duplicates Monet mentioned to Durand-Ruel when he was selecting works for exhibition.

While he was working on the paintings, Monet asked for a photograph of the Houses of Parliament. Although he later said that he had not been able to use it (w. 1764), his request suggests a wish to have another look, perhaps because his notations left him with some uncertainties. The crenelations or pinnacles at the south end are blunt or sharp in different paintings (figs. 16, 17, 49, 52, 55), and the shape of some of the smaller towers varies (figs. 16, 55). These minor details are unimportant in the effect of the mass of the building. Because Monet had changed the shape of the building to suit his composition, a photograph could not substitute for his own experience.

The paintings of the Houses of Parliament (with their simpler composition and lack of interplay of middle- and background elements), more than the views of the bridges, create a sequence of evocative atmospheric effects. Monet developed gradations in density between very foggy views (figs. 49, 55) which he continued to work on even after the exhibition: the Atlanta painting (fig. 55) was made foggier.[85] Shifts in tonality, between these and others (figs. 17, 52, 67) in which pinks and yellows play a more important part, were another variation and a way of integrating these paintings with sunset views where the sun shone through the clouds (figs. 16, 53) and oranges became more significant.

In all of these paintings the artist was trying to represent something translucent with opaque paints. The layered surfaces that he had been developing helped him to achieve this task, for they allowed one color to show through another, without assuming an identity as a shape. The blended and layered colors suggested the instability and ambiguity of fog. But it was not only effects of light and atmosphere that Monet was trying to achieve. In the early 1890s he had told Robinson that he was interested in "mystery."[86] His technique allowed him to conjure up a scene in an open-ended and evocative way.

84. Ibid., W. 1546 and W. 1548 (fig. 41); W. 1572 and W. 1573 (fig. 65); W. 1584 (fig. 20) and W. 1585; W. 1593-95; W. 1596 and W. 1598 (fig. 52); W. 1608 and W. 1609 (fig. 43).

85. Ibid., W. 1601, p. 186, illustrates a photograph showing an earlier state from the time of the exhibition.

86. House, *Monet: Nature into Art*, p. 246 n. 42, quotes a comment from 19 June 1892 on a painting by Raffaelli, "It has a good deal of Monet's *desideratum*, mystery," and on 29 July 1892 Robinson recorded that Monet said a canvas of Deconchy's had too little mystery.

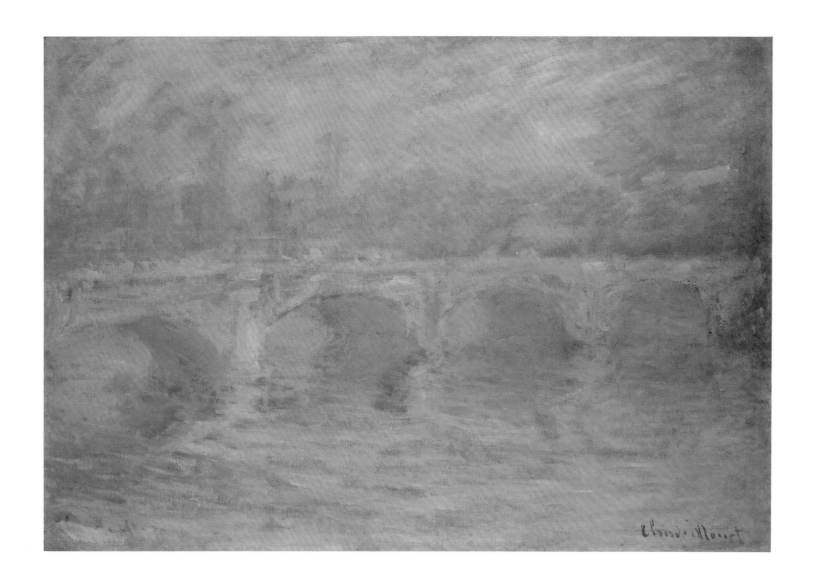

Fig. 63. *Waterloo Bridge, London, at Sunset* [*Effet rose*], 25¾ x 36½ inches
(65.5 x 92.7 cm), National Gallery of Art, Washington, Collection of Mr. and Mrs.
Paul Mellon. Cat. no. 14.

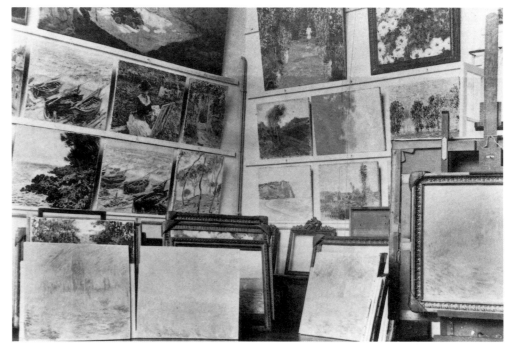

Fig. 64. *Monet's Studio* (at the time of his painting the London series), photograph, Galeries Durand-Ruel.

87. Wildenstein, *Monet*, 4, compared photographs taken at the time of the exhibition to later Durand-Ruel photographs and found that the date of 1902 on W. 1529 (fig. 33) appeared when it was sold in 1910. W. 1573 (fig. 65) was shown in 1904 with the date 1902 but sold in 1905 with the date of 1903. W. 1609 (fig. 43), dated 1904 in the exhibition, was dated 1903 when it was sold in 1909.

Because of the intangible qualities he was trying to create, and because he was thinking of the paintings as a single entity, Monet had a very hard time deciding that the paintings were finished and ready for exhibition. The different dates on the works, between 1899 and 1905, indicate that he may have felt satisfied with particular canvases; however, the dates on individual paintings are not necessarily accurate. Some dates were added and even changed retrospectively.[87] Except for the six paintings sold by 1901, Monet was unwilling to let go of any of the works before the exhibition. The majority of dated paintings (twenty-eight) are dated 1903; Monet was seriously anticipating an exhibition in that year. But he probably continued to work on the signed paintings; he said none was definitively finished (w. 1690).

Monet's wish to work on all the paintings together and his reluctance to say that they were finished was connected with his desire to find effects again and to defer completion. The pressure to produce a satisfactory group of works came from the artist himself. His dealer was eager for him to show, and he knew the works would be well received. But the arrangements for the exhibition of the London paintings showed a pattern of delay and postponement

that Monet had begun with the Cathedrals in 1894. In January 1900 Monet had written Durand-Ruel that he would deliver only things that satisfied him (w. 1492). In January 1903 he wrote that he had promised some Londons and would do his best to manage to have an exhibition; but, he lamented, "I have so much progress to make to do something decent" (w. 1680). Just as he had in working in London, he felt overwhelmed by the difficulties of finishing the works and in May told his dealer that he could not show that year.

> My silence perhaps made you hope that I was more satisfied and that I was finally going to arrive with my canvases. Unfortunately that's not the case. I am exhausted and more disgusted than ever, although still working; but rest is what I have more need of for the moment, while waiting for good weather to arrive so I can go back to work from nature, so this will be my last effort and I will see for sure if I am still good for anything. But for the moment the main thing is to no longer slave at these London paintings which I don't even want to think about any more. (w. 1693)

He wrote to Geffroy in the middle of April 1903 that he had promised the exhibition of "my poor paintings of London" for the beginning of May, but expressed the conflict between his elusive ideal of the painting completed on the spot and his wish to finish the works:

> I'm afraid they'll all be destroyed between now and then. You tell me tranquilly to put them as they are into frames and to show them; no, it would be too stupid to invite people to see much too incomplete experiments. My mistake was to want to retouch them; one so quickly loses a good impression; I regret it very much, because it has made me sick, because that proves my impotence. . . . Now these experiments, these sketches could have been shown; today I have [re]touched *all* of them, I have to go to the very end, no matter what it costs, but the state of nerves and of discouragement I'm in, you can't imagine! (w. 1692)

Interviews and reports by people who visited Monet suggest that both they and the artist valued direct work from nature and were ambivalent about studio work. Writers like Geffroy stressed Monet's directness and truthfulness in working on the spot, and Monet himself fostered this idea. In his 1904 interview, Kahn reported that Monet had said of the Thames paintings:

> I had a devil of a time. I spoiled more than a hundred canvases. It changed all the time. And from one day to the other I didn't find the same landscape. What a hell of a country! After four years of work, and of revisions on the spot, I had to resign myself to only taking notes and to finishing here, in the studio. . . .

Kahn commented: "One distinguishes a shadow of regret in these words: To paint in the studio, for Monet, is no longer to paint."[88]

In 1900 Monet had received a visit from Desmond Fitzgerald, who

88. Kahn, "Le Jardin de Claude Monet."

88

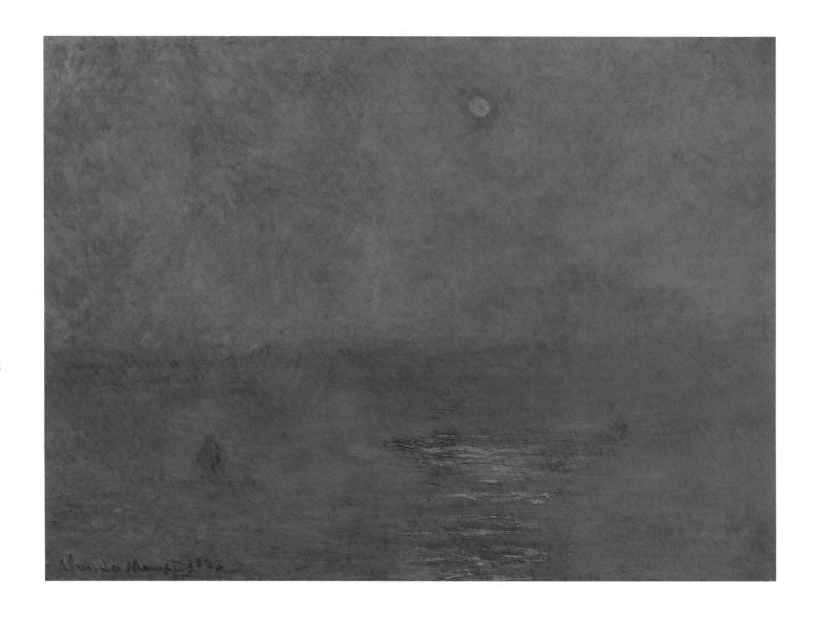

Fig. 65. *Waterloo Bridge: The Sun Through the Mist* [*Soleil dans le brouillard*], 28¾ x 39⅜ inches (73 x 100 cm), National Gallery of Canada, Ottawa.

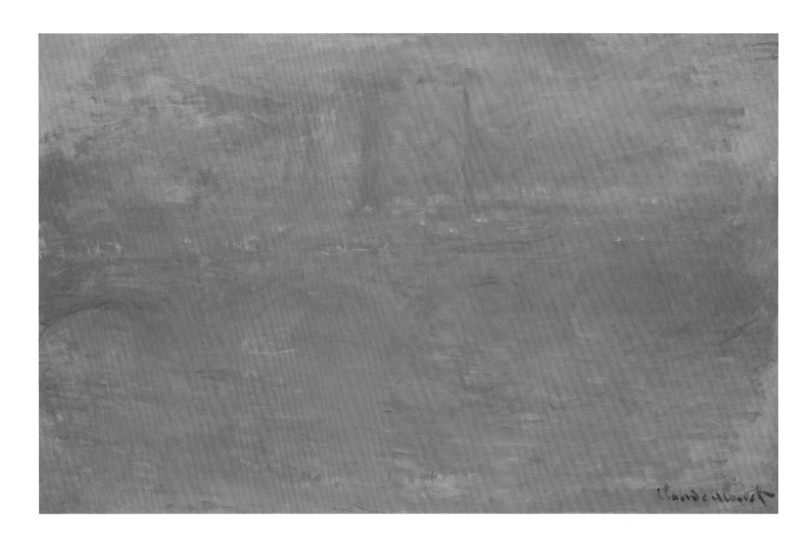

Fig. 66. *Waterloo Bridge, London, at Dusk* [*Le point du jour*], 25⁷/₈ x 30 inches (65.7 x 101.6 cm), National Gallery of Art, Washington, Collection of Mr. and Mrs. Paul Mellon. Cat. no. 9.

described seeing many of the Thames paintings in various stages of completion. He wrote:

> They are really more of a studio series than any of the other works of the master. The original studies were, of course, all made from nature, but the final result has been achieved in the studio, so the works will be known as a Studio Series.[89]

Whereas Kahn seems to have been reflecting Monet's ambivalence, Fitzgerald clearly considered work in the studio to be inferior to that done from nature. Monet had to face this same attitude on the part of his dealer, who no doubt spoke for many people, like Geffroy, who took it as doctrine that Impressionist paintings were directly inspired by nature.

In 1905 Durand-Ruel wrote that he had received a letter from his son, who was also in the business. At an exhibition of Impressionist paintings in London, Georges had had a conversation with William Rothenstein, a British artist, and L. A. Harrison, an American artist with whom Monet had dined, since he was a friend of Sargent.

> Rothenstein having said that your cathedrals didn't seem to have been painted from nature, but from a photograph, my son pointed out that all these canvases were done entirely from nature and from a window across from the cathedral, and that all your paintings were always done entirely from nature. Alexander [Harrison] replied in a loud voice: "Monet paints a lot of paintings in his studio; recently he asked me to send him a photograph of the bridges of London and the Parliament to let him finish his views of the Thames." It would be awkward if this rumor circulated in London and you would do well not to request photographs from people like Harrison.[90]

In fact, Monet's Cathedrals had been extensively repainted in his studio, and Durand-Ruel, perhaps more than his son, would have been very well aware of Monet's extensive "retouching."

In contrast to remarks he made to visitors, Monet's answering letter suggests the extent to which he had abandoned the idea that direct work from nature was valuable in itself. He said that Harrison's remarks stemmed from ill will and jealousy.

> I don't know Mr. Rothenstein . . . but only Mr. Harrison, whom Sargent had asked to have made for me a little photo of the Parliament which I was never able to use. But that doesn't mean much, and whether my Cathedrals, my Londons and other canvases were done from nature or not, that is nobody's business and is not important. I know so many painters who paint from nature and who only do horrible things. That is what your son should reply to these gentlemen. The result is everything. (w. 1764)

The result, in the case of the London paintings, was a unified group of paintings which was, in a sense, a single work of art.

90

89. Desmond Fitzgerald, "Claude Monet: Master of Impressionism," *Brush and Pencil* 15 (1905): 187.
90. Wildenstein, *Monet*, 4: 428, pièce justificative 180, Paul Durand-Ruel to Monet, Paris, 11 February 1905.

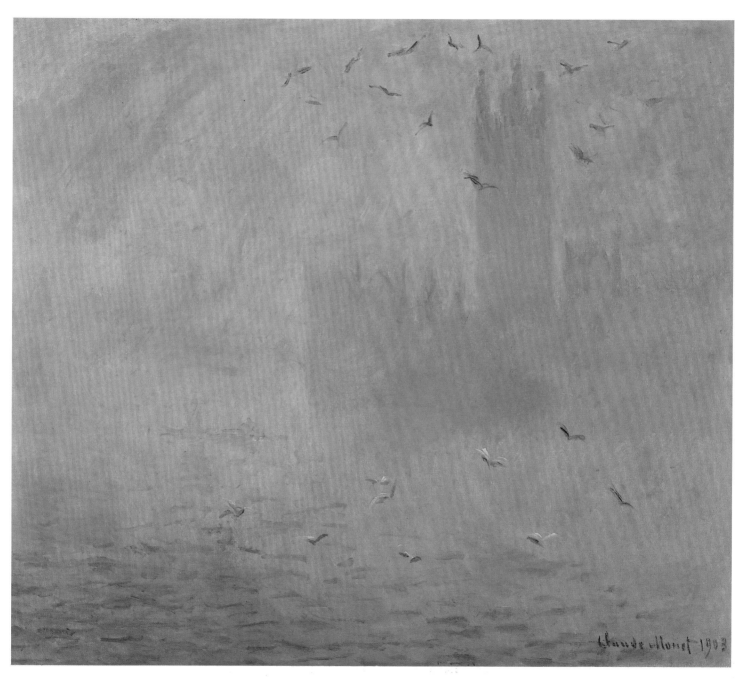

Fig. 67. *The Houses of Parliament, Seagulls*, 31⅞ x 36¼ inches (81 x 92 cm), The Art Museum, Princeton University, bequest of Mrs. Vanderbilt Webb. Cat. no. 23.

The Exhibition

91. Galeries Durand-Ruel, Rue Lafitte–11 Rue
Le Peletier, *Claude Monet: Vues de la Tamise à
Londres*, Exposition du 9 mai au 4 juin 1904
[with identifications from Wildenstein,
Monet, 4]. See page 93.

92. Wildenstein, *Monet*, 4, passim and pièce justi-
ficative 170, J. Durand-Ruel to Cassirer, 7
September 1904. Twelve paintings that had
been in the exhibition were sent to this
dealer. No more Charing Cross Bridge paint-
ings remained, although Durand-Ruel
bought some more later. (Other pièces justi-
ficatives document correspondence with
collectors.) Not all of the Thames paintings
were sold; some remained in Monet's collec-
tion at the time of his death.

Monet's long work on the London paintings culminated in the unified group
of works which he finally allowed to be exhibited in 1904. This did not mean
that he was satisfied with them. He was still uncertain about what they should
be, and his opinion of them changed drastically from day to day. Shortly
before he finally let the paintings be shown, he wrote to Geffroy:

> I'm still struggling with my paintings of London which I will show in May and
> on which I would be so curious to have your opinion, because I'm afraid that
> they're very bad. One day I'm happy with them, only to find they stink the
> next day. (w. 1717)

Monet finally showed the paintings from 9 May to 4 June 1904. He asked
Durand-Ruel to come to help choose the views of London, because there were
a number of duplicates (w. 1720). This last-minute selection was made from a
large group of paintings that Monet was finally willing to part with. Although
some of the views of London were modified later, the exhibition marked the
end of his concentrated work on the series. It was Monet's practice to burn
unsatisfactory canvases and he may have disposed of some of the unfinished
London views in this way, but a few others (figs. 45, 46, 61), which he may have
intended to work on later, remained in his studio at his death. Thirty-six works
were listed in his draft, although thirty-seven appeared in the catalogue, the
last without a number. Eight views of Charing Cross Bridge, eighteen views of
Waterloo Bridge, and eleven views of the Houses of Parliament were shown.[91]
One title mentioned smoke, six mentioned fog or effect of fog, three gray
weather, two overcast, eleven mentioned sun or sun in fog, one veiled sun, and
four sunsets. Three mentioned trains and one gulls. Other works were simply
entitled *Charing Cross Bridge* or *The Thames*.

There is no installation photograph, and the reviews do not give much
information on how the exhibition was arranged. The paintings of different
motifs must have been hung together, since most reviewers mentioned the
three different groups and discussed the succession of effects.

The series was a critical and financial success. Twenty-four works were
bought by Durand-Ruel in 1904, sixteen in 1905, six in 1906, and others from
time to time later. They were sold to many collectors and other dealers over
the next few years for sums of 15,000 francs for Charing Cross and Waterloo
Bridge paintings and 20,000 francs for the Houses of Parliament. Durand-
Ruel's stock of Charing Cross Bridge paintings was depleted soonest. A
number of notable collectors including the Havemeyers, the Palmers, and
Tschoukine are mentioned in the early correspondence on the Thames paint-
ings, and some were bought for museums almost immediately: Dublin in 1905,
Krefeld in 1907.[92]

The poetic prose of the catalogue essay by Octave Mirbeau set the tone for

1904 Exhibition

Charing Cross Bridge

1. *Charing Cross Bridge*, 1902
 [W. 1546, Switzerland, private
 collection]

2. *Trains se croisant*, 1902
 [W. 1533 private collection]

3. *Trains se croisant*, 1902
 [W. 1534, France, private
 collection]

4. *Fumées dans le brouillard;
 impression*, 1902
 [W. 1535, Paris, Musée
 Marmottan (fig. 60)]

5. *La Tamise*, 1903
 [W. 1536, France, private
 collection]

6. *La Tamise*, 1903
 [W. 1537, Lyon, Musée des
 Beaux-Arts]

7. *Brouillard sur la Tamise*, 1903
 [W. 1554, Cambridge, Fogg
 Museum (fig. 15)]

8. *Passage des trains*, 1904
 [W. 1538, Japan, private
 collection]

Waterloo Bridge

9. *Temps gris*, 1900
 [W. 1557, private collection]

10. *Temps couvert*, 1900
 [W. 1556, Dublin, Municipal
 Gallery]

11. *Temps couvert*, 1901
 [W. 1558, Japan, private
 collection]

12. *Matin brumeux*, 1901
 [W. 1559, Philadelphia Museum
 (cat. no. 7, fig. 50)]

13. *Temps couvert*, 1902
 [W. 1560, Hamburger
 Kunsthalle]

14. *Effet de soleil dans la brume*, 1902
 [W. 1577, Venezuela, private
 collection]

15. *Le Soleil dans le brouillard*, 1902
 [W. 1573, Ottawa, National
 Gallery of Canada (fig. 65)]

16. *Temps gris*, 1903
 [W. 1569, Washington, National
 Gallery (fig. 38)]

17. *Effet de soleil*, 1903
 [W. 1589, United States, Mrs.
 Ortiz Echague]

18. *Effet de soleil*, 1903
 [W. 1586, Art Institute of Chicago
 (fig. 12)]

19. *Effet de brouillard*, 1903
 [W. 1580, Leningrad, Hermitage]

20. *Effet de brouillard*, 1903
 [W. 1592, private collection]

21. *Temps gris*, 1903
 [W. 1561, Copenhagen,
 Ordrupgaardsamlingen (cat.
 no. 8, fig. 8)]

22. *Effet de soleil*, 1903
 [unidentified]

23. *Soleil voilé*, 1903
 [W. 1591, United States, private
 collection]

24. *Effet de soleil*, 1903
 [W. 1587, Hamilton, McMaster
 University (cat. no. 16, fig. 19)]

25. *Effet de soleil*, 1903
 [W. 1567, Milwaukee Art Center
 (cat. no. 12, fig. 10)]

26. *Le Soleil dans le brouillard*, 1904
 [W. 1572, United States, private
 collection]

Parliament

27. *Soleil couchant*, 1902
 [W. 1603, United States, Mrs.
 Berenice Richard]

28. *Soleil couchant*, 1903
 [W. 1604, United States, private
 collection]

29. *Soleil couchant*, 1903
 [W. 1598, Washington, National
 Gallery (fig. 52)]

30. *Effet de soleil*, 1903
 [W. 1597, Brooklyn Museum (cat.
 no. 19, fig. 16)]

31. *Effet de brouillard*, 1903
 [W. 1601, Atlanta, High Museum
 (cat. no. 21, fig. 55)]

32. *Effet de brouillard*, 1904
 [W. 1609, New York, Metro-
 politan Museum (fig. 43)]

33. *Effet de soleil dans le brouillard*,
 1904
 [W. 1596, France, private collec-
 tion France]

34. *Les mouettes*, 1904
 [W. 1613, Moscow, Pushkin
 Museum]

35. *Trouée de soleil dans le brouillard*,
 1904
 [W. 1610, Paris, Musée d'Orsay
 (fig. 53)]

36. *Coucher de soleil*, 1904
 [W. 1602, Krefeld, Kaiser
 Wilhelm Museum]

 Effet de brouillard, 1903
 [W. 1611, St Petersburg (cat.
 no. 22, fig. 49)]

93. w. 1723 to Paul Durand-Ruel, Giverny, 28 April 1904. Mirbeau was a novelist and critic who was also an anarchist. He had long admired the Impressionists and was friendly with Monet, Rodin, and Pissarro in the late 1880s and 1890s. He was a close friend of Geffroy. In the 1890s he was established as one of the leading men of letters of the day, and had already written a number of articles on the Impressionists.

94. See Steven Z. Levine, *Monet and his Critics* (New York and London: Garland Publishing, 1976), p. 251.

95. Gustave Kahn, "L'Exposition Claude Monet," *Gazette des Beaux-Arts*, ser. 3, 32 (July 1904): 82. Translated in Stuckey, *Monet: A Retrospective*.

96. Louis Vauxcelles, "Notes d'Art: Une exposition de Claude Monet," *Gil Blas*, 11 May 1904.

97. Ibid.

98. The dichotomy between artists who simply observed nature and those whose works expressed ideas or emotions symbolically is not as simple as the later distinction between Impressionism and Post-Impressionism would make it seem. Morice had included Monet among the masters of Symbolism in 1891, and Mauclair had written sympathetic reviews using Symbolist language. See Levine, *Monet and his Critics*, pp. 126, 428.

99. Octave Mirbeau, [Introduction], *Claude Monet: Vues de la Tamise à Londres*, p. 5.

100. Thiébault-Sisson, "Choses d'art: Claude Monet et ses vues de Londres," *Le Temps*, 19 April 1904. This writer later quoted Monet's statement about the precise return of effects.

much of the criticism. Monet had asked Mirbeau to write the preface at Durand-Ruel's wish, and reported that he was delighted (w. 1723).[93]

The enthusiastic reviews of the London paintings reflected the acceptance of Impressionism in 1904. Initially, in the 1860s and 1870s, what Monet and his friends had been doing had seemed radical, but as other people, including those who showed in the Salon, adopted features of their style, Impressionism began to move into the mainstream, and to be accepted as a naturalistic style. The success of the exhibition of the Thames paintings was due in part to the perception that Monet had been certified as a significant artist.

At the turn of the century, with the Centennial Exposition, writers on art began treating Impressionism in a historical context.[94] In their reviews of the exhibition of Thames paintings, several critics set Monet into a succession of landscape painters. Gustave Kahn spoke of Monet's and Pissarro's discovery of Turner in London as a famous anecdote in the history of Impressionism.[95] Louis Vauxcelles mentioned Claude, Turner, and Monticelli as predecessors and described one of the Houses of Parliament as "flaming like a Turner" (fig. 53).[96] Several writers discussed Monet's earlier career and compared his current recognition to earlier days of ridicule. Vauxcelles wrote, "Monet, who was jeered at and rejected for 20 years, is no longer controversial today." He went on to say that Monet's work, like that of other revolutionary creators—he compared Monet's acceptance to that of Manet, Millet, Ibsen, Verlaine, Wagner, and Redon—was now being admired by uncomprehending snobs and that Salon painters had now taken over the hallmarks of Impressionism.[97]

In beginning his introduction to the exhibition catalogue with an attack on Charles Morice and Camille Mauclair, who had Symbolist sympathies, Mirbeau indirectly alluded to what might be called a generational difference among critics.[98] He contended that the work of art should be felt, and nothing more, and that demands for intellectual, social, political, or philosophical content were unreasonable. The second part of his essay was a poetic evocation of the paintings, whose unity he stressed: "A single theme, in these paintings, single and yet different: the Thames."[99]

Monet was known as perhaps the archetypal Impressionist; therefore, whatever he did was understood as Impressionism. The London paintings were presumed to be truthful notations of Monet's impressions. Some of the critics accepted the works as transparent records of a scene. Thiébault-Sisson described London during the passage of a day, with the mounting and then setting sun creating a varied and amazing spectacle in the fog. He used unusual and poetic words to describe the colors, but stressed the painter's frankness and sincerity.[100]

Only one critic, Elizabeth Pennell, who lived on the Thames, accused Monet of falsity, although she assumed he was sincere. She wrote of unsuccessful

impressions "of a curious green light which does not exist, but which Monet somehow managed to think he saw descending upon the Thames."[101]

Other critics' ambiguities of language suggest that something about the paintings didn't fit neatly into the notion of faithful Impressionist recording which they accepted as the generating principle of the paintings. Many of them resorted to the metaphors of other arts which Symbolist criticism also used; the paintings were poetry, drama, music.

Sometimes their statements suggested that the effects ran counter to ordinary experience: "Nothing could be conceived that is more exact and more unreal than these paintings."[102] Metaphors not only of other arts but also of dream, enchantment, and fantasy appeared in some of the writings, including Mirbeau's preface (which undoutedly inspired some of the other critics). He wrote about the drama of light:

> Infinitely changing and nuanced, somber or enchanted, anguishing, delicious, flowery, terrible, of reflections on the waters of the Thames; of the nightmare, of dream, of mystery, of the conflagration, of the furnace, of chaos, of floating gardens, of the invisible, the unreal, of all this, of nature, this special nature of this prodigious city, created for painters and which painters up till M. Claude Monet didn't know how to see, could not express.[103]

Arsène Alexandre wrote, "This goes further than painting. It's an enchantment of atmosphere and light. London appeared fantastic in its fogs of dream, colored by the magic of the sun."[104] Kahn wrote of the illusion of "perpetually changing phantasmagories" and described the works as if they were the products of imagination, but then denied that that was the case.

> Claude Monet has noted rare moments, perhaps unique, so rich in beauty, in diversity, in luxury, that they could for an instant seem as unreal as the realm of Queen Mab; that before these pyrotechnics of gold, of pink, of rose-pink, of rose-red, of pink pricked with red, of purple, of meadow green, of golden or deep blue-green, one could dream for an instant of believing that these visions must be based on some principle of polychrome ornamentation, rather than due to an absolute obedience to nature. One could believe that these are harmonies on a theme furnished at the instant of the sketch though the graces of the hour and its alliances of colors, harmonies executed not by a virtuoso, but by a master composer of symphonies, gifted with a profound sensibility and an infinitely fresh, lively, and inventive imagination. None of this is the case. These are paintings elaborated after exact notations.[105]

Kahn's reference to elaboration "after exact notations" was a way of accounting for Monet's complex painterly effects while retaining the idea of direct inspiration. Kahn's notion of obedience to nature implied a more submissive attitude than Monet's goal of painting directly from nature in seeking to render his impressions (w. 2626); however, the issue of the paintings' relation to nature was a problematic one for the critics as it was for Monet.

95

101. [Elizabeth Pennell], "Monet in London," *Star*, 31 May 1904, reprinted in Flint, *Impressionists in London*, p. 335.

102. "Notes d'art: La Tamise, par M. Claude Monet," *Liberté*, 18 May 1904.

103. Mirbeau, [Introduction], p. 5 For a discussion of the notion of Monet's "fantasy" as a projection of an inner spectacle interpreted in Freudian terms see Steven Z. Levine, "Monet, Fantasy, and Freud," *Psychoanalytic Perspectives on Art*, ed. Mary Mathews Gedo (Hillsdale, N.J.: The Analytic Press, distributed by Lawrence Eribaum Associates, 1985), 1: 29-55.

104. Arsène Alexandre, " La Tamise, par Claude Monet," [1904], [unidentified clipping in the Durand-Ruel press book].

105. Gustave Kahn, "L'Exposition Claude Monet," pp. 83-84. See Levine, *Monet and his Critics*, pp. 277-80, for a discussion of this article.

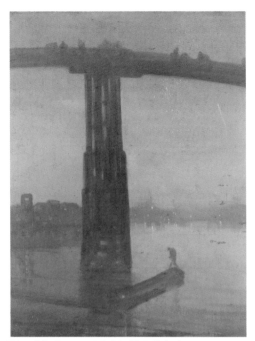

Fig. 68. James McNeill Whistler, *Nocturne in Blue and Gold: Old Battersea Bridge*, ca. 1872-75, 26¼ x 19¼ inches (66.7 x 48.9 cm), Tate Gallery, London.

The London paintings were constituted of resistant matter—paint that was in places thickly crusted. How Monet created the illusion of atmospheric effects was a matter of interest to at least some of the critics. The extent to which they accepted the idea of willfulness in the work affected the way they talked about its physical qualities. Thiébault-Sisson, and a number of the other critics who focused on the unfolding spectacle, didn't make any mention of the paintings themselves. Some claimed that the three landscapes were varied only by time and weather, minimizing other differences among them.[106]

Others acknowledged the paint surface. Pennell compared Monet's technique unfavorably to that of Whistler (fig. 68), whose biographer she was and whom she considered to be his direct inspiration:

> In the nocturnes you feel the thing itself, not its interpretation in paint. Monet slaps you in the face with his brush, which London never does. . . . the wonderful, translucent, shimmering, impalpable beauty of a grey day, the mystery of a blue night, and the gorgeousness of a London sunset cannot be expressed by the technique of Claude Monet, at least not satisfactorily. . . . It is the paint that hits you and not the picture.[107]

Several critics claimed that Monet had "pushed back the limits of painting."[108] "Le Masque Rouge" wrote:

> In his desire to paint the most complex effects of light, Monet seems to have attained the extreme limits of art. . . . Monet has attempted to step over the limits which were assigned to him. He wanted to explore the inexplorable, to express the inexpressible, to build, as the popular expression has it, on the fogs of the Thames! And what is worse, he succeeded.[109]

Mirbeau, who argued that the work of art was mysterious and came from the spirit, used the word "miracle"—which recurs in other critics' writings on the exhibition—in discussing the conjuring up of the illusion.

> It's a miracle. It's almost a paradox that one can, with impasto on canvas, create impalpable matter, imprison the sun . . . to make shoot forth from this Empyrean atmosphere, such splendid fairylands of light. And yet, it's not a miracle, it's not a paradox: it's the logical outcome of the art of M. Claude Monet.[110]

The Symbolist poet Kahn's extended review in the *Gazette des Beaux-Arts* was the only article that discussed individual works. He evoked the unity of paint and effect in the way that he described them.

> In one of his *Setting Suns*, the star is a visible heavy disk from which filter the most subtle variations of color; elsewhere [fig. 10] it spreads, sulfured, Gomorrahean, in violet, purplish, and orange clouds, and its reflections lap on a heavy water of rose, blue, green, with pink mica glints everywhere bloodied with points of red. Sun breaking through the fog [fig. 53] lights a fleeciness of air and water, melded, changing color in a single rhythm. . . . Waterloo Bridge,

106. "Notes d'art: La Tamise, par M. Claude Monet."
107. Pennell, "Monet in London," p. 335.
108. "Notes d'art: La Tamise, par M. Claude Monet."
109. Le Masque Rouge, "Notes d'Art: l'Exposition Claude Monet," *L'Action*, 12 May 1904.
110. Mirbeau, [Introduction], p. 8.

under skies of different moods, carries a stream of carriages; a fairy-like play of light rushes under the violet shadow of the arches, and touches of sun light the windows of an industrial tower, a lighthouse in the weightless smoke. . . . Here, the water grows languid, there it rushes as if troweled; there it is oily and soft, caressing, with little plumes curling on the end of wavelettes; it looks cut by a powerful rake which makes the precious stones sparkle, or as the light on the river is dimmed by a fleecy and mottled wall of fog, its waves move slowly, in procession, their slow crests strewn with bouquets.

In a *Gray Day* [fig. 38] violet smoke arrives from an invisible boat to die by the gray and blue arches of the bridge.[111]

Although one sort of criticism suggested the more or less effortless recording of effects, another emphasized Monet's hard work.[112] Mirbeau, whose earlier account of Monet at work had contributed to the idea of instantaneous execution and notions that Impressionist works were hastily and carelessly done, pointed out that these paintings resulted from a deliberate effort.[113] Perhaps echoing the artist, Mirbeau insisted on the importance of the result:

These paintings represent four years of thoughtful observations, of ceaseless efforts, of prodigious labor. . . . To speak of the doubt, the discouragements, the shooting anxieties through which M. Claude Monet passed before this gigantic task he had set himself, this isn't anyone's business, and besides it is the usual lot of scrupulous artists. Only the result is important.[114]

The unity of effect suggested to some critics that Monet had arrived at essential qualities of the motif. Mirbeau said Monet had "expressed London in its own essence,"[115] and Lecomte wrote: "Never has Monet, despite the dazzling enchantment of his palette, attained such a vaporous subtlety, such power of abstraction and synthesis."[116]

Reservations about Monet's enterprise centered on the question of whether it was enough to base art on response to nature. Morice wrote that the exhibition was "perfect art—of which it's impossible not to sense the limits." Of Monet's instinctive approach he wrote: "One can only say he developed himself; this formula doesn't imply, doesn't permit any development." He felt that only some fault in the vision of a genius could transform this painting into "the door opened on the unknown, the desirable unknown, the divine, the unexpected."[117]

One of the critics, possibly Gabriel Mourey, left behind questions of the works' relation to nature in discussing their abstract vision of color. He considered the works as "chromatic variations," and compared Monet's compositions to those of Debussy:

In the one, the melody winds around the Word and the sonority colors it with infinitely subtle nuances; in the paintings of the other, a chromatic scale, where the eye discerns the least coma, stands at the service of an acute sensibility which varies ceaselessly and gains in refinement with each blink.[118]

111. Kahn, "L'Exposition Claude Monet," pp. 86-87.
112. For instance, Alexandre, " La Tamise, par Claude Monet," referred to "a long period of hard labor," and Georges Lecomte, "Un Homme," *Petit République Socialiste,* 11 May 1904, pointed to Monet's "noblesse" in struggling for new creations when he could sell the least sketch.
113. See Levine, *Monet and his Critics,* p. 272.
114. Mirbeau, [Introduction], p. 7. This sounds very much like the letter Monet wrote the next year to Durand-Ruel (w. 1764). Was Mirbeau echoing Monet, or vice versa?
115. Ibid., p. 8.
116. Lecomte, "Un Homme." Kahn, "L'Exposition de Claude Monet," p. 85, quoted a passage from Roger Marx on Monet's synthesis.
117. Charles Morice, "Art moderne: Vues de la Tamise à Londres par Claude Monet," *Mercure de France,* 50 (June 1904): 796-97. He also said that Monet's art was "tout en décor—je ne dis pas décoratif." See Levine, *Monet and his Critics,* pp. 273-75, on Morice and *décor.*
118. "Exposition Claude Monet," *Les Arts de la vie,* 1 (June 1904): 390-91, partially quoted and discussed in Levine, *Monet and his Critics,* pp. 284-88.

This critic's appreciation of Monet's color effects in their own right approached the artist's work in a way that anticipated the interest of later twentieth-century viewers in his formal innovation. The early critics had shown a sensitivity to emotional nuances in the works, as well as to Monet's extraordinary effects of light. But the language of naturalistic description, which provided the basis for most of the thinking about Thames series, seemed to be strained by the task of coming to terms with the paintings. The critics and buyers marveled at the works, but found them complex and elusive.

The Thames Paintings & the Twentieth Century

119. Charles Morice, "XXe Salon des indépendants," *Mercure de France*, 50 (May 1904): 405-19. He asked if Gauguin, Denis, Guerin were Impressionists and answered yes and no.

120. John Elderfield, *The "Wild Beasts": Fauvism and its Affinities*, exhibition catalogue (New York: Museum of Modern Art, 1976), pp. 32, 151 n. 60, claims the 1904-05 season was dominated by Neo-Impressionism. "The popularity of Neo-Impressionism among younger artists is to be explained not only by the way it transformed Impressionism into a readily learned system (and one that admitted high color) but also, more prosaically, by Signac's presidency of the Salon des Indépendants. To work in this style was to gain his influential support."

The exhibition that Monet had worked on for so long took place at a time of transition between nineteenth- and twentieth-century art. Some critics felt that Impressionism's day was over, although they didn't have a clear idea of what was next. Morice, a supporter of Gauguin and Symbolism, wrote about the Salon des Indépendants the month before he reviewed the Thames paintings. "Impressionism drags on beyond its real life. Today it's only a formula, a recipe." He added, "Excellent [Neo-Impressionist] artists such as Cross and Luce continue it legitimately. But how can you avoid seeing new tendencies in most of those who claim to be descendants of Monet?" (He discussed Sérusier, Ranson, Bonnard, Roussel, Vuillard, and Munch.)[119] Morisot and Sisley had died during the 1890s. Pissarro had died in 1903, and Cézanne would die in 1906. Other artists with whom Monet had worked and exhibited, such as Degas and Renoir, were still active, but none of them had as long and productive a career ahead of him as Monet, who would live until 1926. In 1904 Neo-Impressionism attracted younger artists, as a "scientific" and easily learned systematization of Impressionist ideas, and as a politically expedient way of gaining notice.[120] Impressionism was still a presence, but a new generation was questioning its naturalism and its intuitive approach.

Monet's chromatic innovations were relevant to the concerns of the young artists who would receive the name "*les Fauves*" the next year, and the Thames paintings had immediate successors. In 1905 and 1906 Derain painted a group of views of London, including Charing Cross, Waterloo, and Westminster Bridges, and the Houses of Parliament (fig. 69).[121] Derain wrote that these visits to London were arranged by Vollard, who "sent me in hope of renewing completely at that date the expression which Claude Monet had so strikingly achieved which had made a very strong impression on Paris in the preceding years."[122]

Ambrose Vollard as a dealer was interested in capitalizing on the success of the Thames exhibition. But Derain's comment about "renewing" also suggests that Monet's work was only a starting point. As well as painting many of the same subjects, Derain used colors akin to Monet's—pinks, yellows, blues, blue-

greens, and some sunset oranges and reds—but applied them differently. In contrast to Monet's soft, shifting, unbounded areas of color, he used a Neo-Impressionist mosaic of separate touches or broad areas of a single color. Rather than giving an impression of fog through a soft overall blending of color, he frankly contrasted one hue to another. With his deemphasis on the naturalistic reference, this artist, like his contemporaries, saw Monet's use of color as something that could be explored in its own right.

For the Cubists, and for that direction of modernist thinking—stemming from Roger Fry, among others—that emphasized construction and saw Cézanne as the precursor, Monet's later work seemed to have little relevance. Monet himself was a less active participant in the art scene than earlier. With the exception of a trip to Venice in 1908, he remained at his home at Giverny. He did not return to the contemporary and urban subjects that had interested him before. Instead he painted in his garden, pursuing elusive changes of light, working with subtle shifts of color, especially in his massive paintings of Water Lilies (fig. 70).

The Thames paintings had prepared the way for the Water Lilies in their treatment of extremely subtle nuances of light and reflection and in their evocation of fluctuating, unstable effects with layers of color. The palette of many of the later Water Lilies is similar to the blues, violets, and pinks of the Thames paintings. The unprecedented scope of the Thames series— by far the largest Monet had undertaken—and its use of atmospheric effects to create an internal coherence were taken up in a different way in the enveloping monumental Water Lilies that were Monet's final legacy.

It was not until the advent of Abstract Expressionism that Monet's later work came to be appreciated as an expression of twentieth-century sensibility. His uses of color, his surface qualities, and his paint handling were looked at with new eyes.[123] Clement Greenberg wrote in 1957 that Monet found what he was looking for, "which was not so much a new principle as a more comprehensive one: and it lay not in Nature, but in the essence of art itself, in its 'abstractness.'" He wrote that the avant-garde had missed chiaroscuro structure in the later Monet, "but there is nothing in experience that says that chromatic, 'symphonic' structure . . . cannot supply its place."[124]

Greenberg's formalist emphasis belongs to a particular moment of twentieth-century criticism, but does not accord with Monet's view, which emphasized nature, and it does not exhaust the possibilities for discussion. The continuing interest of the Thames paintings lies in their multiplicity of interpretations. They can be appreciated for their naturalism, their abstraction, their expression of emotional states, their evidence of artistic process.

Looked at in light of Monet's letters and the evidence they themselves

Fig. 69. André Derain, *Houses of Parliament*, 31⅛ x 33⅞ inches (79.1 x 86.1 cm), Musées Nationaux, donation Pierre Levy.

99

121. *Charing Cross Bridge* (New York, private collection); *Big Ben*, (Musées Nationaux, donation Pierre Lévy); *Westminster Bridge* (Musées Nationaux, col. Max Kagnovitch); *Bridge on the Thames* (Musée de l'Annociade, St. Tropez). Elderfield, *The "Wild Beasts,"* pp. 35, 39, 46, 152 n. 82, illustrates several of these and discusses the problems of dating these works.
122. Letter to the President of the Royal Academy London, 15 May 1953, cited in ibid., p. 152 n. 82.
123. The pioneering article was William Seitz, "Monet and Abstract Painting," *College Art Journal* 16 (Fall 1956): 34-46, reprinted in Stuckey, *Monet: A Retrospective.*
124. Clement Greenberg, "The Later Monet," *Art and Culture* (Boston: Beacon Press, 1962), pp. 37-45. He found a paradox involved in Monet's later development; accepting the idea of the artist's wish to paint what he saw, he felt that Monet had been led to an almost hallucinatory perception of nature.

125. Shiff, in *Cézanne and the End of Impressionism*, especially in Chapter 5, discusses the intersection of Impressionist and Symbolist interests, and the way in which "there was much of 'symbolist' value in impressionist naturalism" (p. 49).

126. Gimpel, *Diary of an Art Dealer*, p. 74, reported on a conversation in 1919, when Monet was seventy-nine, in which he said he was not afraid of death: " 'Painting makes me suffer: all my old work with which I'm not satisfied and the impossibility of doing well every time. Yes, each time I begin a canvas I hope to produce a masterpiece, I have every intention of it, and nothing comes out that way. Never to be satisfied—it's frightful.' . . . He also said that he was happier in the days when he sold his canvases for 300 francs to sincere buyers. 'It's much easier for today's snobs to give me 20,000 francs.' "

provide of a prolonged struggle, these paintings can also be seen as the products of an artist who had always been interested in rendering impressions and in the expression of sensation, but for whom personal and subjective criteria played an increasingly important role. This was in part the particular manifestation of Monet's long-term interests at the turn of the century, as he, like some of his contemporaries, sought a technical means for the expression of subjective experience.[125]

It was characteristic of Monet, and perhaps built into his way of working, that he never felt the result was definitive.[126] His search for the impossible can be seen as resulting from his internal struggles, or can seem the inevitable lot of an artist attempting to deal with fugitive effects and to establish his own criteria for completion.

Monet's whole enterprise was in some respects problematic and contradictory. In creating such subjective works, and in working in a way that was only partially based on nature, Monet was pushing at the boundaries of twentieth-century art. In finding a way to deal with flux and change in his paintings, and with his wish to give them a transcendent unity, he was coming to grips with an uncertainty that is a condition of later art.

Fig. 70. *Water lilies*, 1920-22, 78¾ x 167¾ inches (200 x 426.2 cm), The Saint Louis Art Museum, gift of the Steinberg Charitable Fund.

Exhibition Checklist

1. *Charing Cross Bridge, London*
 25 x 35⅜ inches (63.5 x 89.9 cm)
 Signed and dated lower right:
 Claude Monet 99
 Shelburne Museum,
 Shelburne, Vermont (27.1.4-70)
 Fig. 40, W. 1521

2. *Charing Cross Bridge* [*Temps couvert*]
 23⅞ x 36 inches (60.7 x 91.4 cm)
 Signed and dated lower right:
 Claude Monet 1900
 Museum of Fine Arts, Boston
 Gift of Janet Hubbard Stevens in
 memory of her mother, Jane
 Watson Hubbard (1978.465)
 Fig. 14, W. 1526

3. *Charing Cross Bridge*
 26 x 36½ inches (66 x 92.7 cm)
 Indianapolis Museum of Art
 Gift of Various Contributions
 (65.15)
 Fig. 61, W. 1530

4. *Charing Cross Bridge*
 [*Reflets sur la Tamise*]
 24½ x 39½ inches (62.2 x 100.3 cm)
 Signed lower right: *Claude Monet*
 The Baltimore Museum of Art
 The Helen and Abram Eisenberg
 Collection (BMA 1945.94)
 Fig. 31, W. 1532

5. *Charing Cross Bridge*
 28¾ x 39⅜ inches (73 x 100 cm)
 Signed and dated lower left:
 Claude Monet 1903
 The Saint Louis Art Museum
 (22:1915)
 Fig. 41, W. 1548

6. *Waterloo Bridge*
 25¾ x 36½ inches (65.4 x 92.7 cm)
 Signed and dated lower left:
 Claude Monet 1900
 Santa Barbara Museum of Art
 Bequest of Katherine Dexter
 McCormick in memory of her
 husband, Stanley McCormick
 (1968.20.7)
 Fig. 26, W. 1555

7. *Waterloo Bridge, Morning Fog*
 [*Matin brumeux*]
 25⅞ x 39⁷/₁₆ inches
 (65.7 x 100.2 cm)
 Signed lower right: *Claude Monet*
 Philadelphia Museum of Art
 Bequest of Anne Thomson as
 a memorial to her father,
 Frank Thomson, and her
 mother, Mary Elizabeth Clarke
 Thomson (54-66-6)
 Fig. 7, W. 1559

8. *Waterloo Bridge, temps gris*
 25¾ x 39½ inches
 (65.4 x 100.3 cm)
 Signed and dated lower right:
 Claude Monet 1903
 The Ordrupgaard Collection,
 Copenhagen
 Fig. 8, W. 1561

9. *Waterloo Bridge, London, at Dusk*
 [*Le pont du jour*]
 25⅞ x 40 inches (65.7 x 101.6 cm)
 Signed lower right: *Claude Monet*
 National Gallery of Art,
 Washington
 Collection of Mr. and Mrs. Paul
 Mellon (1983.1.27)
 Fig. 66, W. 1564

10. *Waterloo Bridge* [*Effet de soleil*]
 25½ x 39 inches (65 x 99 cm)
 Signed and dated lower left:
 Claude Monet 1903
 Denver Art Museum (1935.15)
 Fig. 28, W. 1565

11. *Waterloo Bridge*
 [*Effet de soleil avec fumees*]
 26 x 39¾ inches (66 x 101 cm)
 Signed and dated lower left:
 Claude Monet 1903
 The Baltimore Museum of Art
 The Helen and Abram Eisenberg
 Collection (BMA 1976.38)
 Fig. 11, W. 1566

12. *Waterloo Bridge, effet de soleil*
29¹/₁₆ x 36⁵/₈ inches (73.8 x 93 cm)
Signed and dated lower left:
Claude Monet 1903
Milwaukee Art Museum
Bequest of Mrs. Albert T.
Friedmann (M1950.3)
Fig. 10, W. 1567

13. *Waterloo Bridge*
25³/₄ x 36¹/₂ inches (65.4 x 92.7 cm)
Signed and dated lower right:
Claude Monet 1903
Worcester Art Museum,
Worcester, Massachusetts
(1910.37)
Fig. 37, W. 1568

14. *Waterloo Bridge, London, at Sunset*
[*Effet rose*]
25³/₄ x 36¹/₂ inches (65.5 x 92.7 cm)
Signed lower right: *Claude Monet*
National Gallery of Art,
Washington
Collection of Mr. and Mrs. Paul
Mellon (1983.1.28)
Fig. 63, W. 1583

15. *Waterloo Bridge*
26 x 32 inches (66 x 81.3 cm)
Signed lower right: *Claude Monet*
Lowe Art Museum, University
of Miami
Gift of Ione T. Staley (60.057.000)
Fig. 20, W. 1584

16. *Waterloo Bridge* [*Effet de soleil*]
25³/₄ x 39¹/₂ inches (65.4 x 100.3 cm)
Signed and dated lower right:
Claude Monet 1903
McMaster University, Hamilton,
Ontario, Canada
Gift of Herman Levy Esq., O.B.E.
(1984.007.0043)
Fig. 19, W. 1587

17. *Waterloo Bridge, London*
[*Effet de soleil*]
25³/₈ x 39¹/₂ inches (64.5 x 100.3 cm)
Signed and dated lower right:
Claude Monet 1903
The Carnegie Museum of Art,
Pittsburgh
Acquired through the generosity
of the Sarah Mellon Scaife
family (67.2)
Fig. 62, W. 1588

18. *Waterloo Bridge, Clouded Sun*
25¹/₂ x 39¹/₄ inches (64.8 x 99.7 cm)
Signed and dated lower right:
Claude Monet 1903
Memorial Art Gallery of the
University of Rochester
Gift of the estate of Emily and
James Sibley Watson (53.6)
Fig. 56, W. 1590

19. *Houses of Parliament,*
Effect of Sunlight
32 x 36¹/₄ inches (81.2 x 92 cm)
Signed and dated lower left:
Claude Monet 1903
The Brooklyn Museum
Gift of Mrs. Grace Underwood
Barton (68.48.1)
Fig. 16, W. 1597

20. *Houses of Parliament*
[*Tours de Westminster*]
31⁷/₈ x 36¹/₄ inches (81 x 92 cm)
Signed lower right: *Claude Monet*
The Art Institute of Chicago
Mr. and Mrs. Martin A. Ryerson
Collection (1933.1164)
Fig. 17, W. 1600

21. *Houses of Parliament in the Fog*
[*Effet de brouillard*]
32 x 36³/₈ inches (81.3 x 92.4 cm)
Signed and dated lower right:
Claude Monet 1903
High Museum of Art
Great Painting Fund purchase
in honor of Sarah Belle
Broadnax Hansell (60.5)
Fig. 55, W. 1601

22. *Houses of Parliament, London*
[*Effet de brouillard*]
32¹/₂ x 36¹/₂ inches (82.5 x 92.7 cm)
Signed and dated lower right:
Claude Monet 1904
Museum of Fine Arts,
St. Petersburg, Florida
Gift of Mr. and Mrs. Charles
Henderson and Friends
of Art (79.5)
Fig. 49, W. 1611

23. *The Houses of Parliament, Seagulls*
31⁷/₈ x 36¹/₄ inches (81 x 92 cm)
Signed and dated lower right:
Claude Monet 1903
The Art Museum,
Princeton University
Bequest of Mrs. Vanderbilt Webb
(79.54)
Fig. 67, W. 1612

Selected Bibliography

For a more complete bibliography see Rewald, *The History of Impressionism*, and Wildenstein, *Monet*.

Alexandre, Arsène. "La Tamise, par Claude Monet." [1904], [unidentified clipping in the Durand-Ruel press book].

"Au Jour le jour: Claude Monet." *Soleil*, 10 May 1904.

Bowness, Alan. *The Impressionists in London*. Exhibition catalogue. London: Arts Council of Great Britain, 1973.

"Chez les marchands de tableaux à Paris: Visite à M. Durand-Ruel—Il vend les Claude Monet pour 20,000fr. chacun." *New-York Herald*, 19 May 1904.

Claude Monet: Vues de la Tamise à Londres. Paris: Galeries Durand-Ruel, 1904.

"L'Exposition Claude Monet." *L'Aurore*, 19 May 1904.

Fitzgerald, Desmond. "Claude Monet: Master of Impressionism." *Brush and Pencil* 15 (1905): 181-95.

Flint, Kate. *Impressionists in England: The Critical Reception*. London, Boston, Melbourne and Henley: Routledge & Kegan Paul, 1984.

Geffroy, Gustave. *Claude Monet: sa vie, son temps, son oeuvre*. 2 vols. Paris: G. Crès & Cie., 1922.

Gimpel, René. *Diary of an Art Dealer*. Translated by John Rosenberg. New York: Farrar, Straus and Giroux, 1966.

Gordon, Robert, and Forge, Andrew. *Monet*. New York: Harry N. Abrams, 1983.

*Guillemot, Maurice. "Claude Monet." *Revue Illustré* 13 (March 1898) [no pagination].

Herbert, Robert. "Method and Meaning in Monet." *Art in America* 67 (September 1979): 104-05.

Homes of the Passing Show. London: The Savoy Press, 1900.

House, John. "The Impressionist Vision of London." In *Victorian Artists and the City: A Collection of Critical Essays*, edited by Ira Bruce Nadel and F. S. Schwarzbach. New York, Oxford, etc.: Pergamon Press, n.d.

_____. *Monet: Nature into Art*. New Haven and London: Yale University Press, 1986.

Isaacson, Joel. "Monet's Views of the Thames." *Bulletin of the Art Association of Indianapolis* 52 (1965): 44-51.

_____. *Observation and Reflection: Claude Monet*. Oxford: Phaidon, 1978.

*Kahn, Gustave. "L'Exposition Claude Monet." *Gazette des Beaux-Arts* ser. 3, 32 (July 1904): 82-88.

*Kahn, Maurice. "Le Jardin de Claude Monet." *Le Temps*, 7 June 1904.

Lecomte, Georges. "Un Homme." *Petit République Socialiste*, 11 May 1904.

Levine, Steven Z. *Monet and His Critics*. New York and London: Garland Publishing, 1976.

_____. "Monet's Series: Repetition, Obsession." *October*, no. 37, 65-75.

Le Masque Rouge. "Notes d'Art: l'Exposition Claude Monet." *L'Action*, 12 May 1904.

Morice, Charles. "Art moderne: Vues de la Tamise à Londres par Claude Monet." *Mercure de France* 50 (June 1904): 795-97.

"Notes d'art: L'exposition Claude Monet." *L'Action*, 12 May 1904.

"Notes d'art: Une exposition de Claude Monet." *Gil Blas*, 11 May 1904.

"Notes d'art: La Tamise, par M. Claude Monet." *Liberté*, 18 May 1904.

[Pennell, Elizabeth.] "Monet in London." *Star*, 31 May 1904. Reprinted in Flint, *Impressionists in London*, 335.

Pellier, Henri. "Petits Salons." *Petite République Socialiste*, 3 June 1904.

*Perry, Lila Cabot. "Reminiscences of Claude Monet from 1889 to 1909." *American Magazine of Art* 18 (1927): 119-125.

Piper, David. *Artists' London*. New York: Oxford University Press, 1982.

Pissarro, Camille. *Letters to his Son Lucien*. Edited by John Rewald. Rev. ed. Santa Barbara and Salt Lake: Peregrine Smith, 1981.

Rashdall, E. M. "Claude Monet." *The Artist*, July 1888. Reprinted in Flint, *Impressionists in England*, 308.

Rewald, John. *The History of Impressionism*. 4th rev. ed. New York: Museum of Modern Art, 1973.

Seiberling, Grace. *Monet's Series*. New York and London: Garland Publishing, 1981.

Seitz, William. "Monet and Abstract Painting." *College Art Journal* 16 (Fall 1956): 34-46.

Shiff, Richard. *Cézanne and the End of Impressionism*. Chicago: University of Chicago Press, 1984.

Stuckey, Charles F., ed. *Monet: A Retrospective*. New York: Park Lane, 1985.

Thiébault-Sisson, François. "Choses d'art: Claude Monet et ses vues de Londres." *Le Temps*, 19 avril 1904.

*_____. "Un nouveau musée parisien: Les Nymphéas de Claude Monet: L'Orangerie des Tuileries." *Revue de l'art ancien et moderne* 52: 41-52.

Trévise, Duc de. "Le Pèlerinage de Giverny." *Revue de l'art ancien et moderne* 51 (1927): 42-50, 121-39.

Vauxcelles, Louis. "Notes d'Art: Une exposition de Claude Monet." *Gil Blas*, 11 May 1904.

Wildenstein, Daniel. *Claude Monet: Biographie et catalogue raisonné*. 4 vols. Lausanne and Paris: Bibliothèque des arts, 1974-85.

*Articles marked with asterisk are collected in Stuckey, *Monet: A Retrospective*.

103

DATE DUE		
NOV 21 1990 F		
MAR 2 8 1991		
3 MAY 9 A.M.		
MAY 1 6 1991		
NOV 1 2 '94		
DEC 9 '94		
MAY 1 6 1995 F		

104

Photo Credits

Figs. 12, 17: © 1986 The Art Institute of Chicago. All Rights Reserved.

Fig. 14: © 1985 Museum of Fine Arts, Boston. All Rights Reserved.

Fig. 20: © Lowe Art Museum. All Rights Reserved.

Figs. 22, 48: From Daniel Wildenstein's *Claude Monet: Biographie et catalogue raisonné* (Paris and Lausanne, 1985).

Fig. 28: © Denver Art Museum.

Figs. 39, 42: Courtesy International Museum of Photography at George Eastman House.

Fig. 43: © 1980 The Metropolitan Museum of Art

Figs. 44, 47, 64: Courtesy Galerie Durand-Ruel.

Fig. 59: © 1988 The Art Institute of Chicago. All Rights Reserved.

Fig. 61: © Indianapolis Museum of Art.

Fig. 69: © Musées Nationaux, Paris.